MANCHESTER & SALFORD IN PHOTOGRAPHS

JON SPARKS

AMBERLEY

ACKNOWLEDGEMENTS

As always, I've had fantastic support from my partner and critical friend, Bernie Carter.

I'd also like to thank individuals and establishments who granted access and in some cases went out of their way to help, especially Joe Hoyle at Victoria Baths Trust and Fergus Wilde at Chetham's Library.

For much help in identifying some of the less obvious locations, many thanks to Helen Colley. I'm only sorry I couldn't use more of them.

ABOUT THE PHOTOGRAPHER

Jon Sparks is a freelance photographer and writer specialising in the outdoors. He's known Manchester from an early age and has been based in nearby Lancashire all his working life. While he's had fantastic experiences in New Zealand, Pakistan, Jordan and other far-flung spots, many of his favourite places are much closer to home.

Alongside pure landscape photography, he's worked extensively on outdoor pursuits; in fact, he'd argue that there's no hard boundary between the two. He's tried most activities but has a special love of all things bike, whether skinny-tyred road bikes or mountain bikes. He's also a lifelong hill-walker, scrambler and 'resting' rock climber. He's picked up awards for both writing and photography, and indeed has written extensively about photography.

First published 2020

Amberley Publishing
The Hill, Stroud
Gloucestershire, GL5 4EP

www.amberley-books.com

Copyright © Jon Sparks, 2020

The right of Jon Sparks to be identified as the Author of this work has been asserted in accordance with the Copyrights, Designs and Patents Act 1988.

ISBN 978 1 4456 9834 2 (print)
ISBN 978 1 4456 9835 9 (ebook)

British Library Cataloguing in Publication Data.
A catalogue record for this book is available from the British Library.

Typesetting by SJmagic DESIGN SERVICES, India.
Printed in the UK.

INTRODUCTION

Almost all of these photos were shot within a ten-month period (April 2019–February 2020), an inevitable consequence of trying to stay current within a dynamic and rapidly changing urban landscape – and fortuitously finished just before Covid-19 lockdown descended. However, my acquaintance with Manchester and Salford goes back a lot further. Working on this book has been a journey of both discovery and rediscovery.

Earliest memories include shopping trips, by train, in the 1960s. There have been events at venues like the Free Trade Hall, Bridgewater Hall and more recently Salford Quays, and one unforgettable night in the velodrome during the 2002 Commonwealth Games. Riding that same track myself, even at half the speed of the pros, is another treasured experience.

Background research, as well as the actual photography, has renewed my awareness that Manchester and Salford have always punched above their weight in historical and cultural terms. Above all, they were the world's first industrial cities. And, as world leaders, their story is fittingly cosmopolitan. From the Romans to the Flemish weavers of the Middle Ages, offcomers have left their mark. Karl Marx and Friedrich Engels first met here. New Zealander Ernest Rutherford first split the atom in Manchester, and graphene was first isolated by two Russian-born physicists.

In the city of the world's first inter-city railway terminus, it's fitting that I reached the great majority of locations by a mix of public transport and foot-slogging. Central Manchester, in particular, has become much more walkable and pleasant to visit, thanks principally to the Metrolink, Britain's biggest and best light rail system.

Manchester skyline from Heaton Park

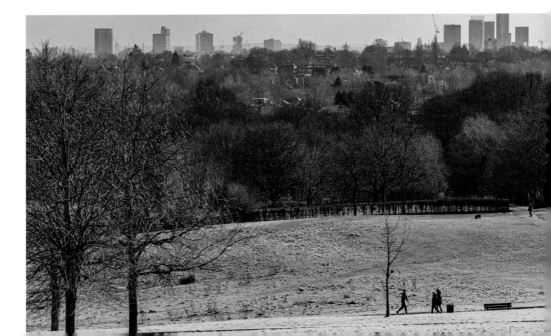

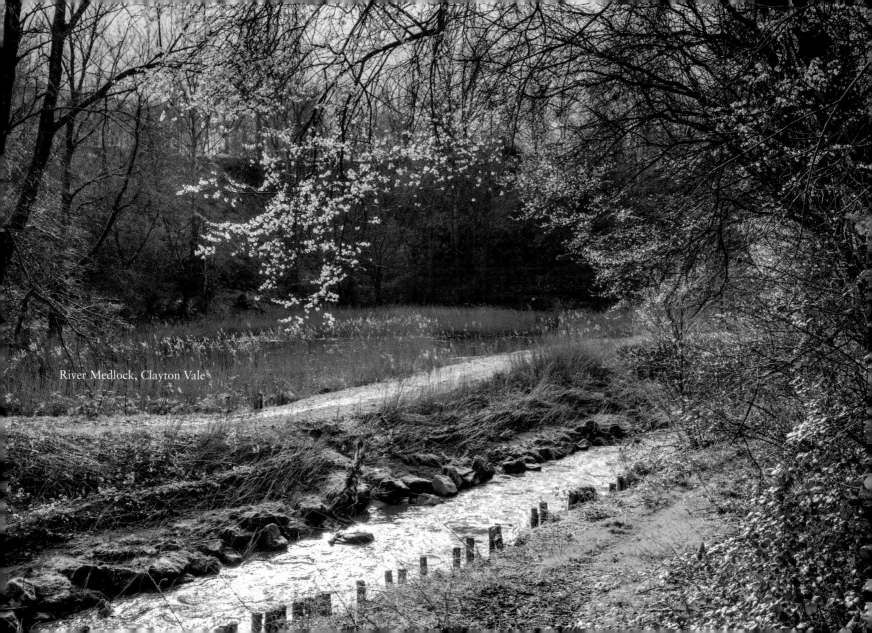

River Medlock, Clayton Vale

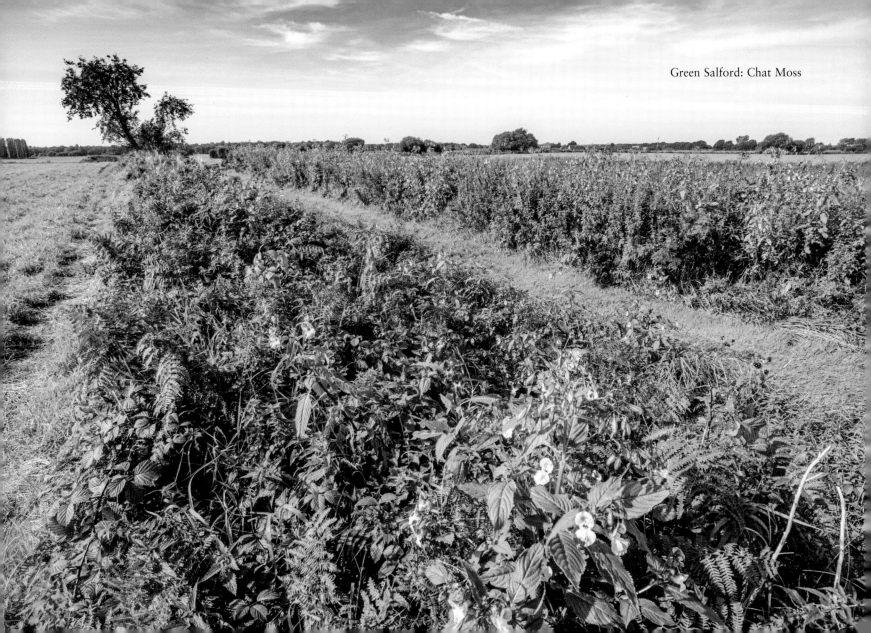

Green Salford: Chat Moss

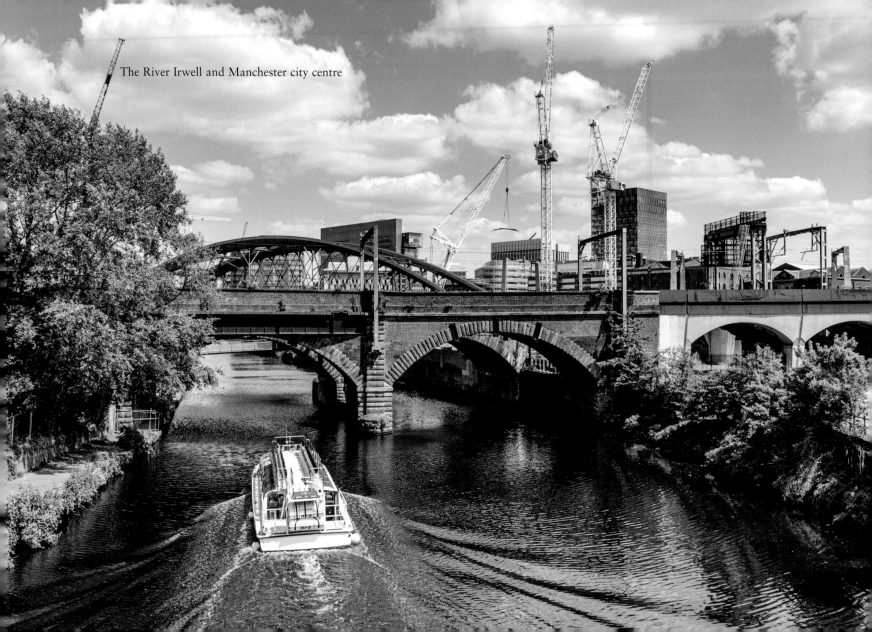

The River Irwell and Manchester city centre

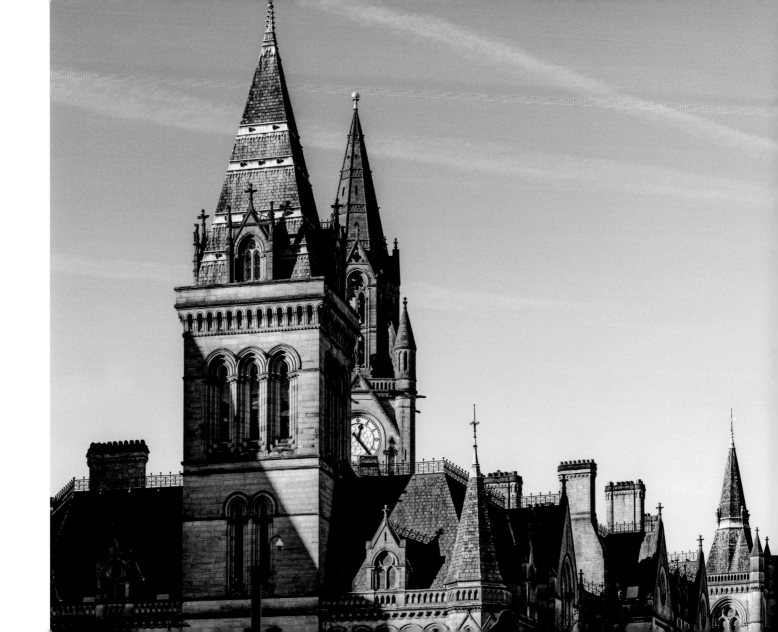

Roofscape,
Manchester
Town Hall

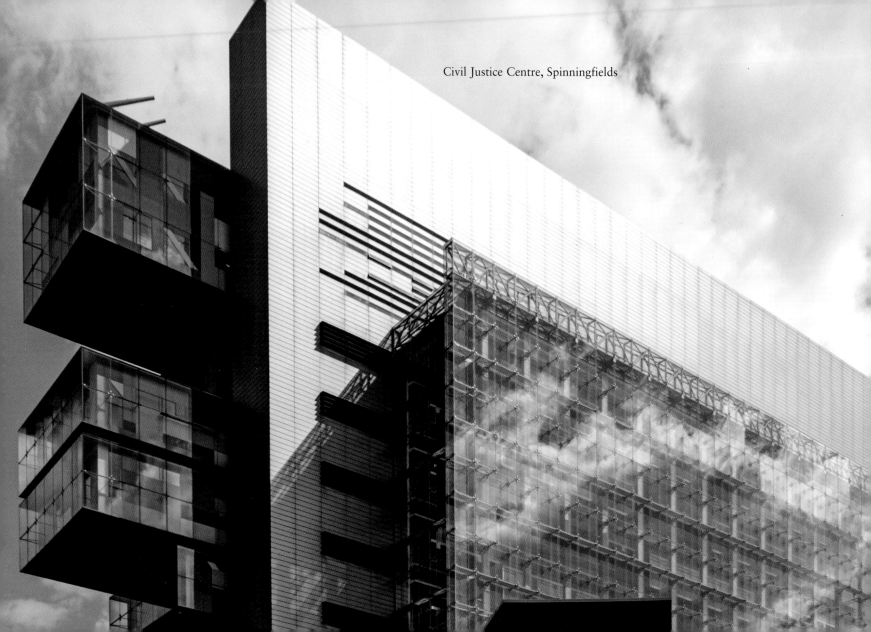

Civil Justice Centre, Spinningfields

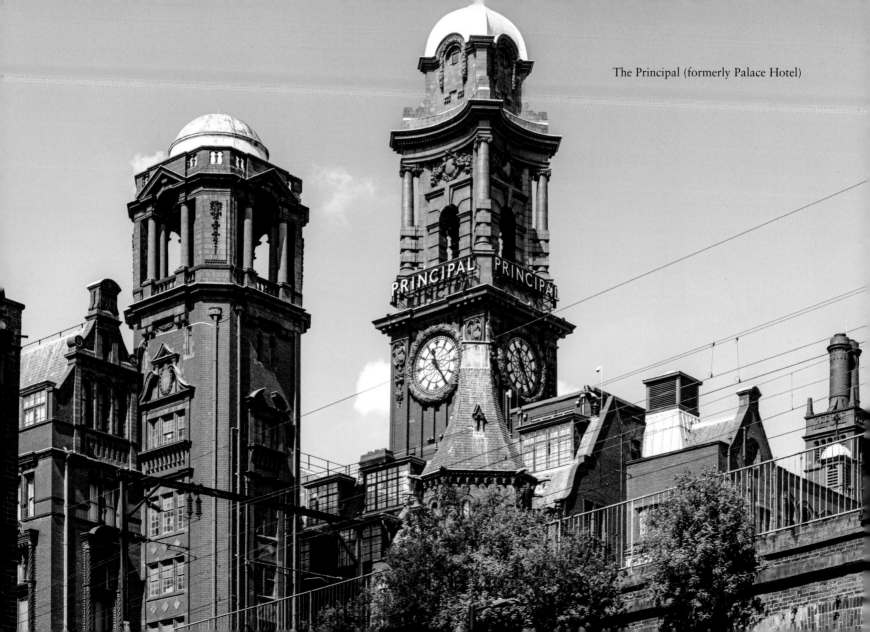

The Principal (formerly Palace Hotel)

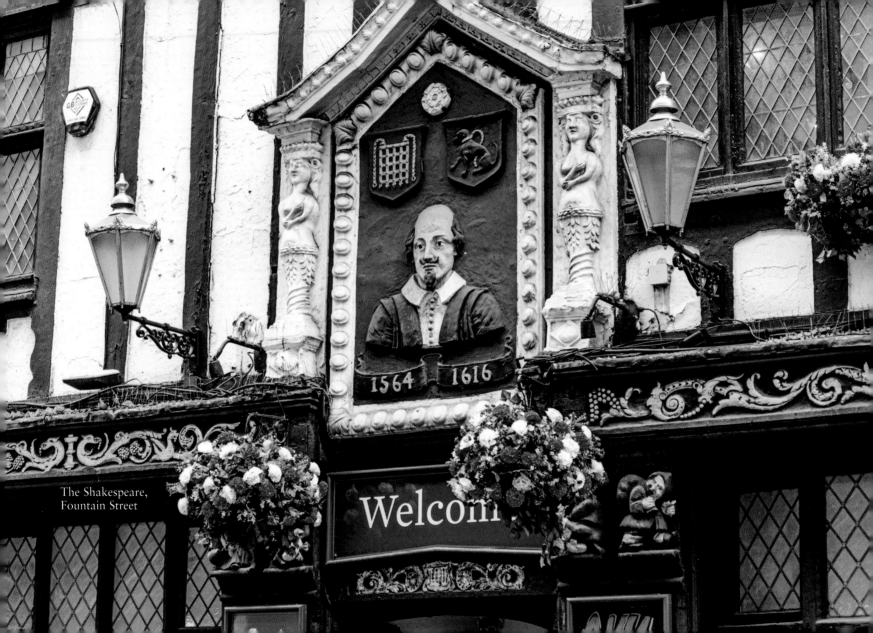

The Shakespeare,
Fountain Street

Welcom

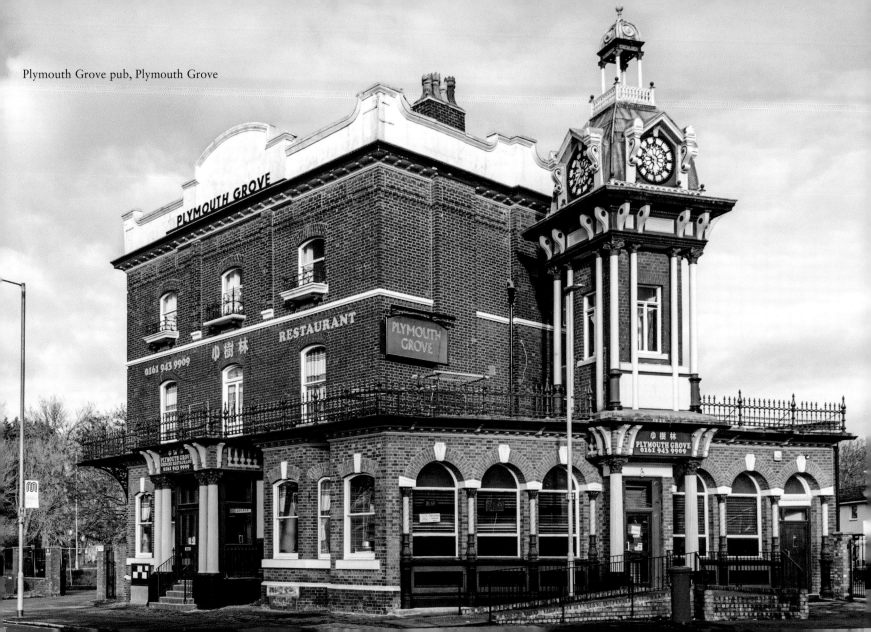

Plymouth Grove pub, Plymouth Grove

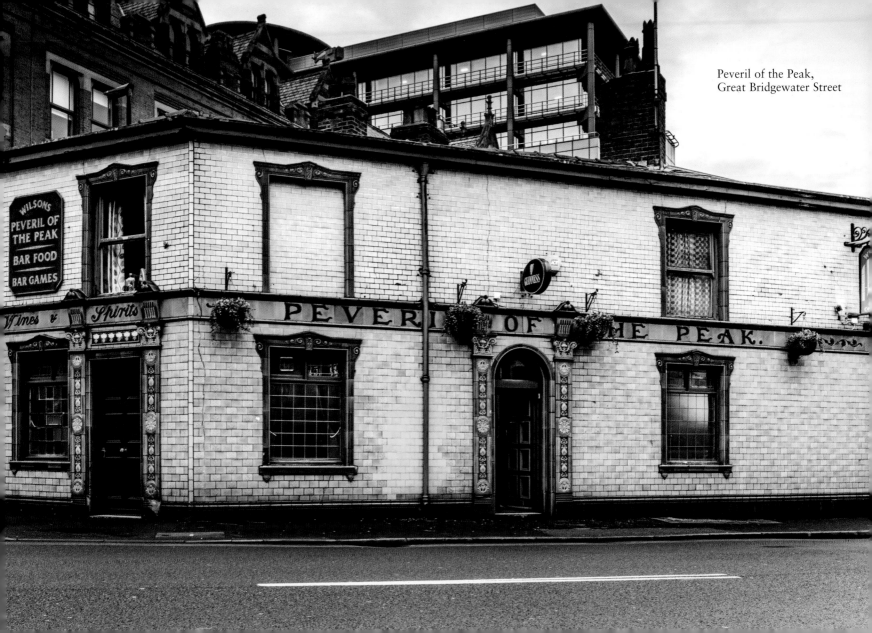

Peveril of the Peak,
Great Bridgewater Street

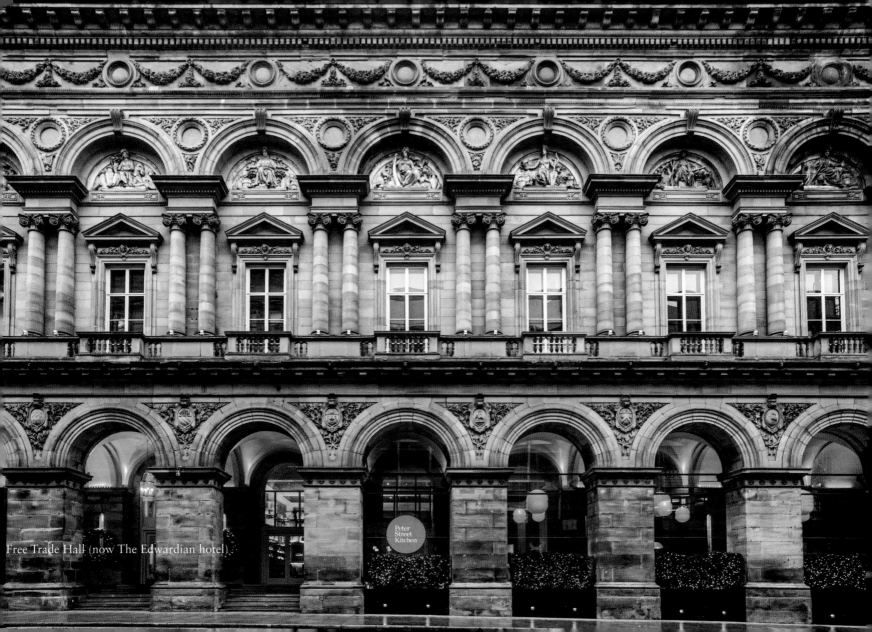
Free Trade Hall (now The Edwardian hotel)

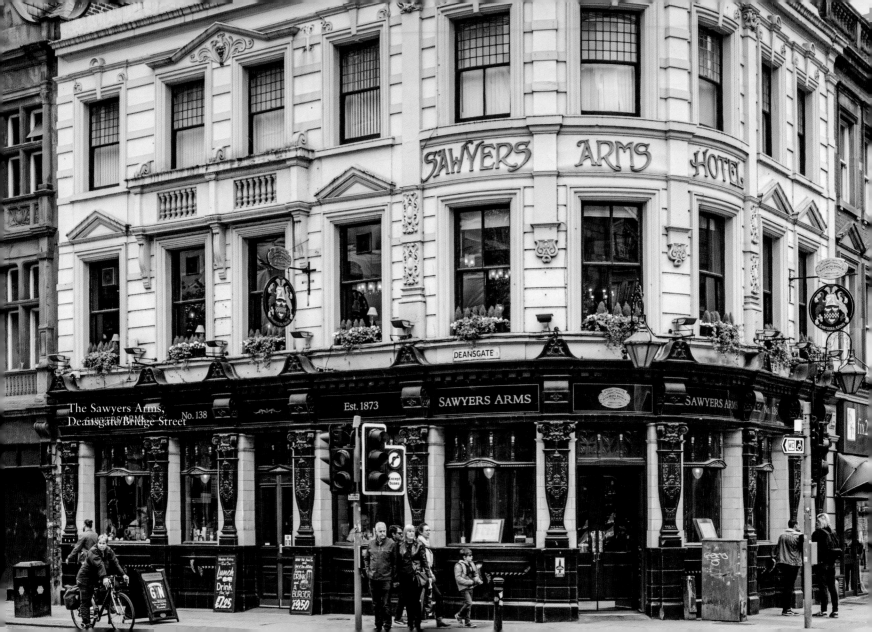

The Sawyers Arms,
Deansgate/Bridge Street

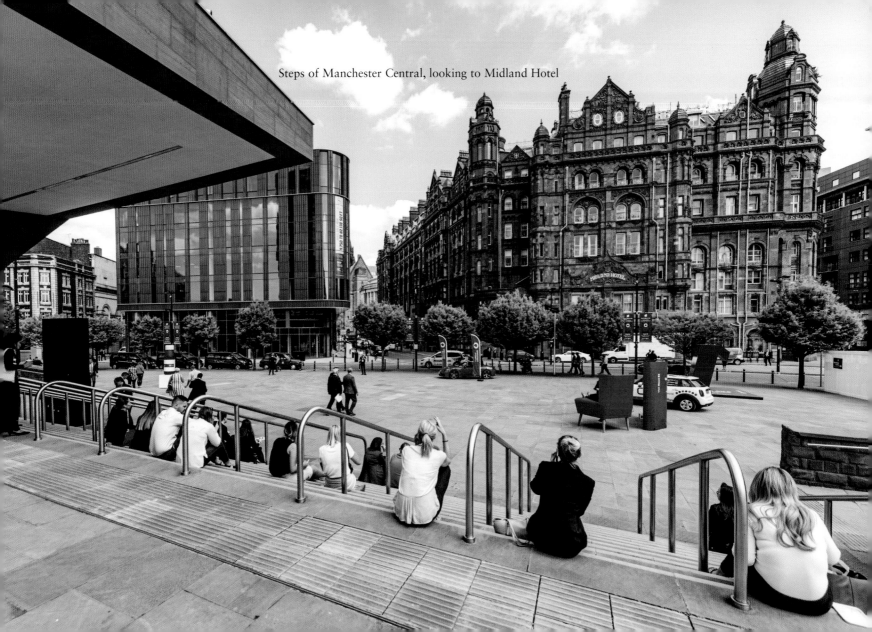
Steps of Manchester Central, looking to Midland Hotel

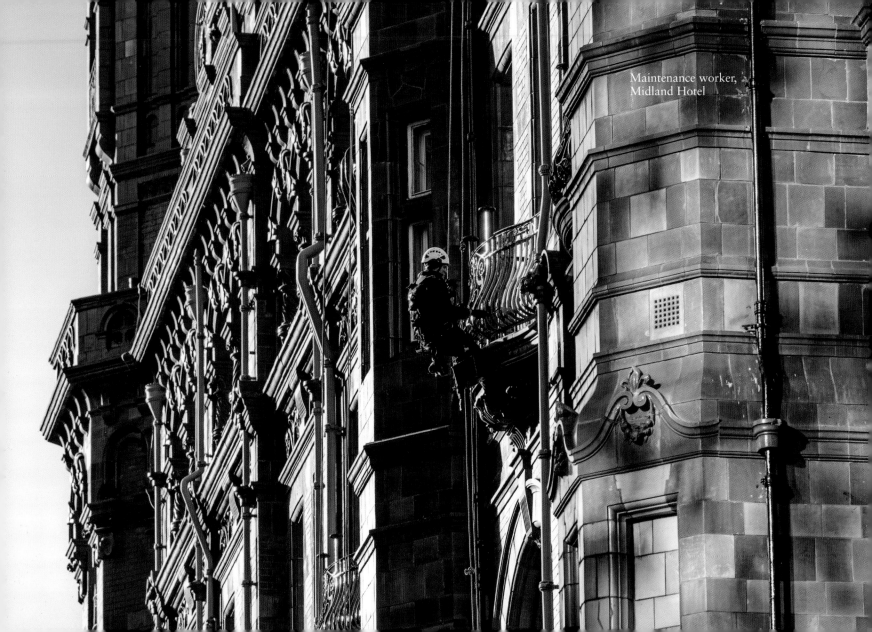

Maintenance worker,
Midland Hotel

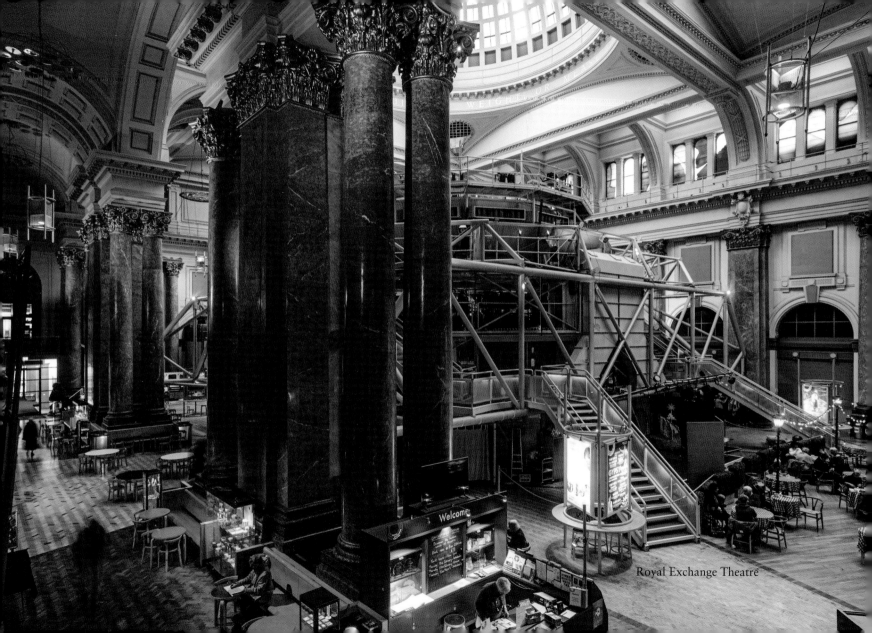

Royal Exchange Theatre

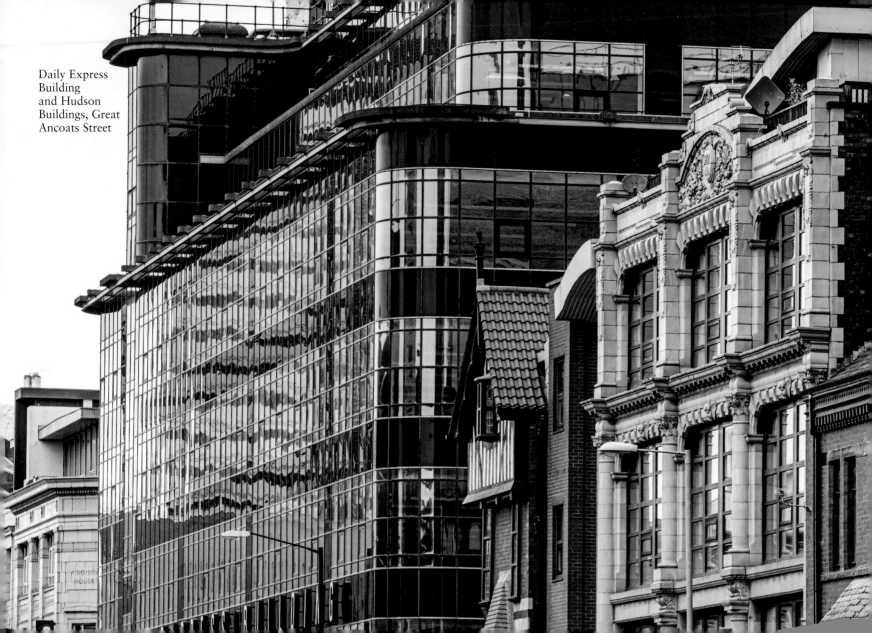

Daily Express
Building
and Hudson
Buildings, Great
Ancoats Street

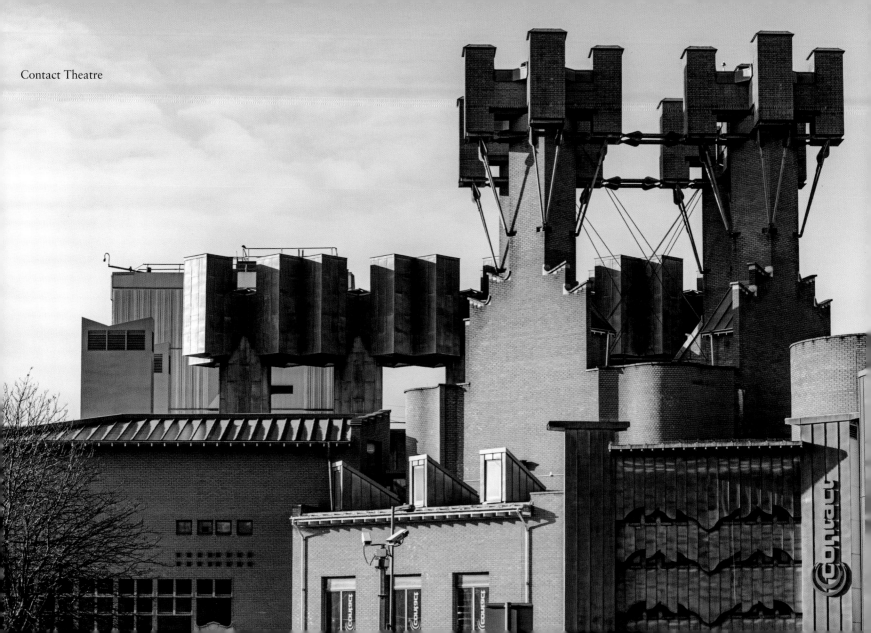

Contact Theatre

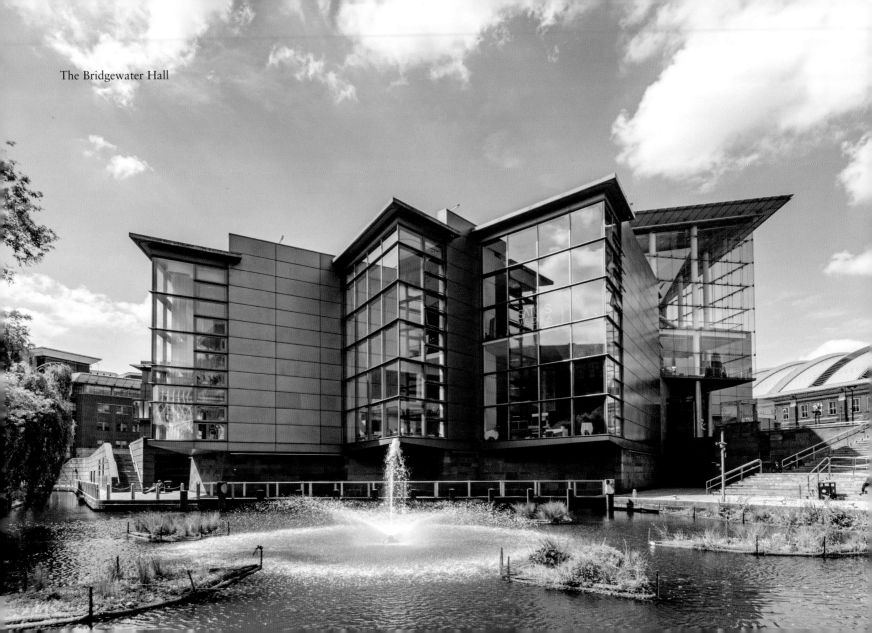

The Bridgewater Hall

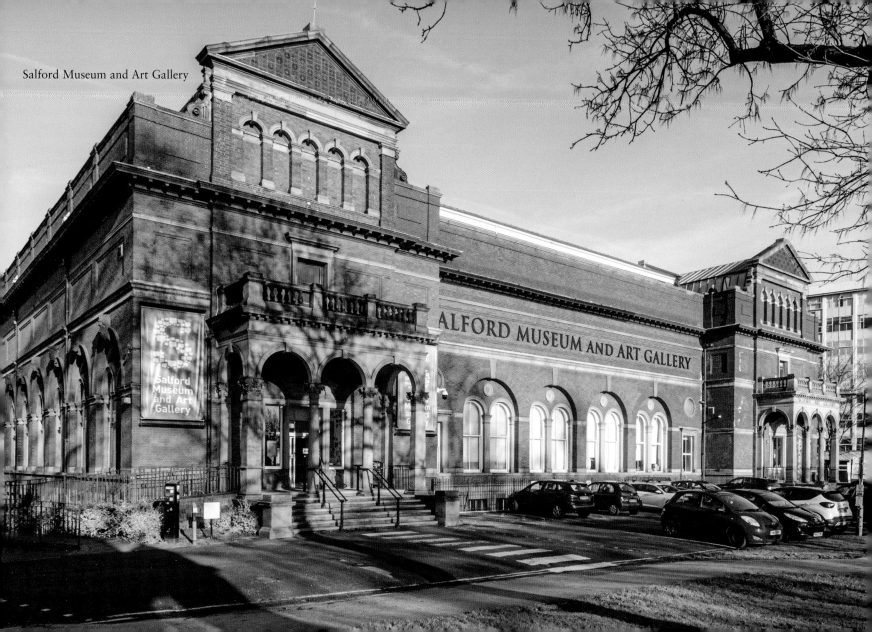

Salford Museum and Art Gallery

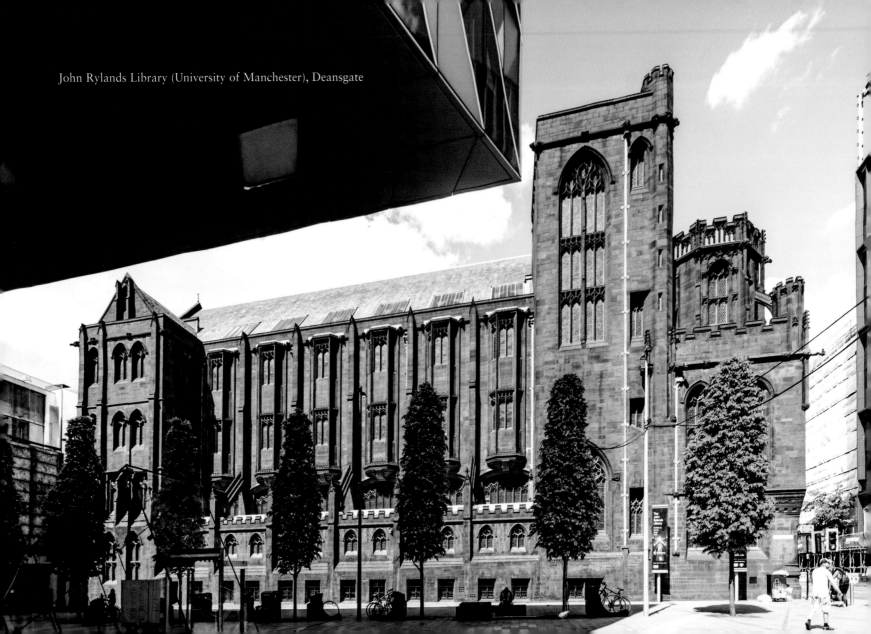
John Rylands Library (University of Manchester), Deansgate

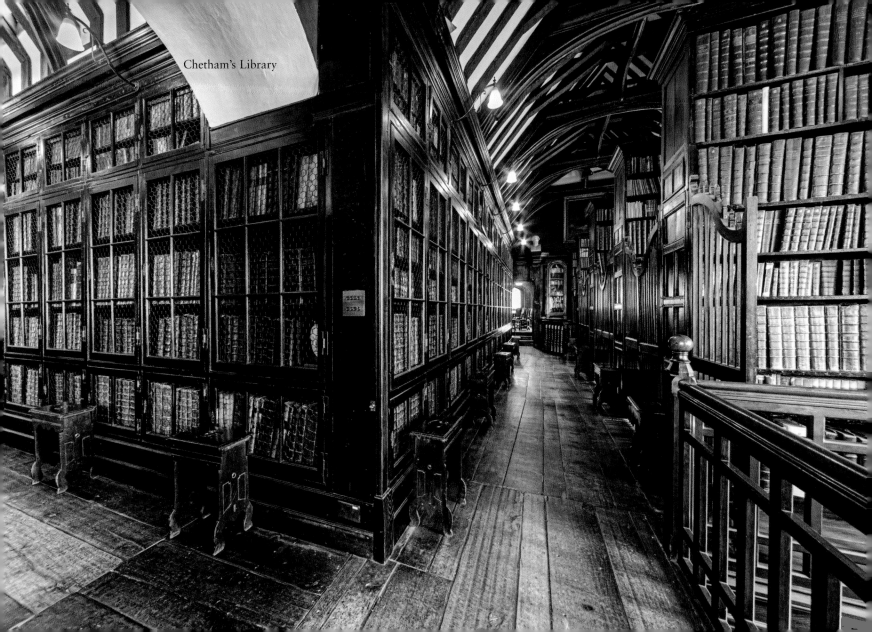
Chetham's Library

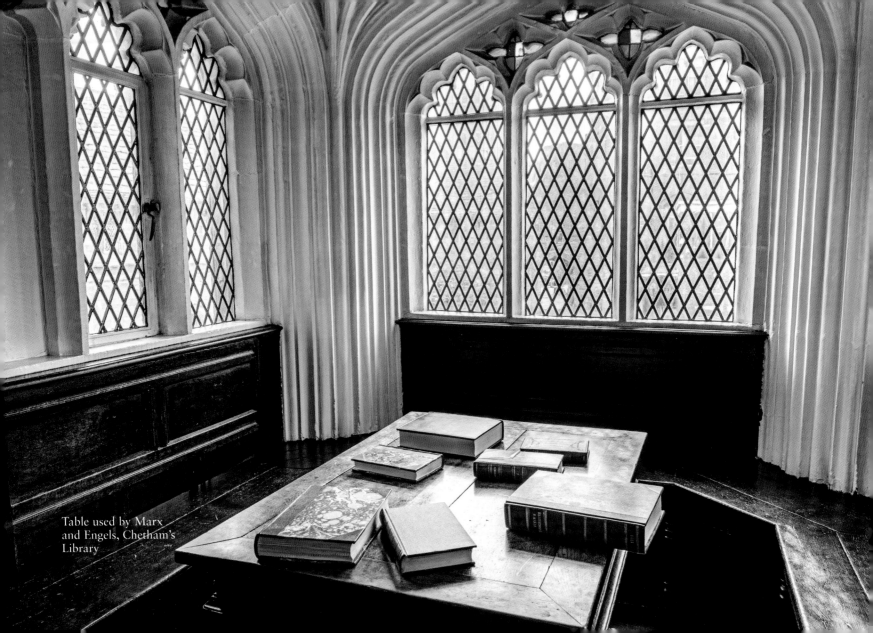

Table used by Marx and Engels, Chetham's Library

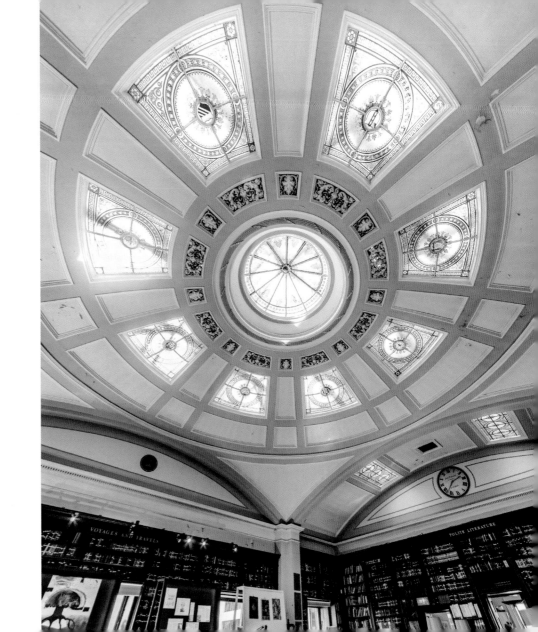

The Portico Library

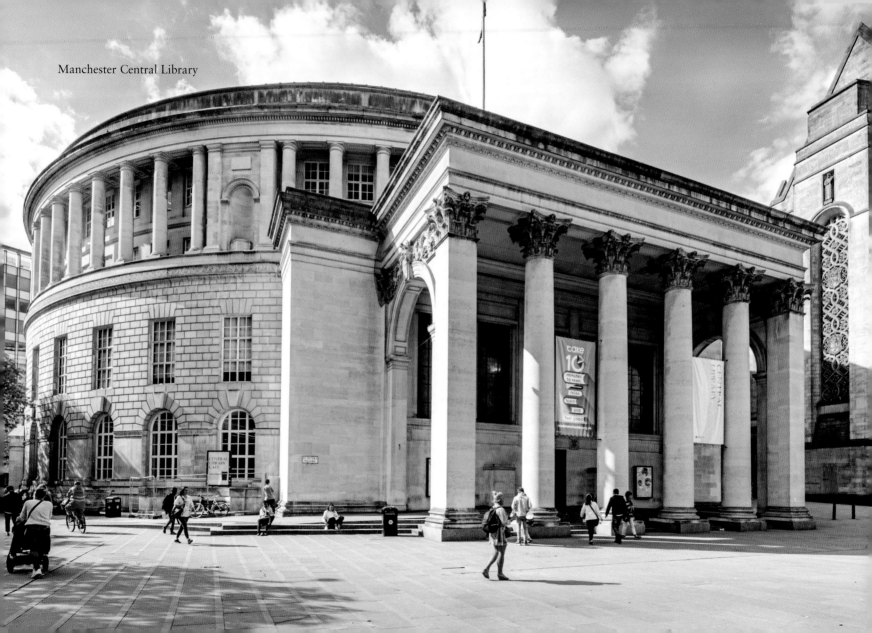
Manchester Central Library

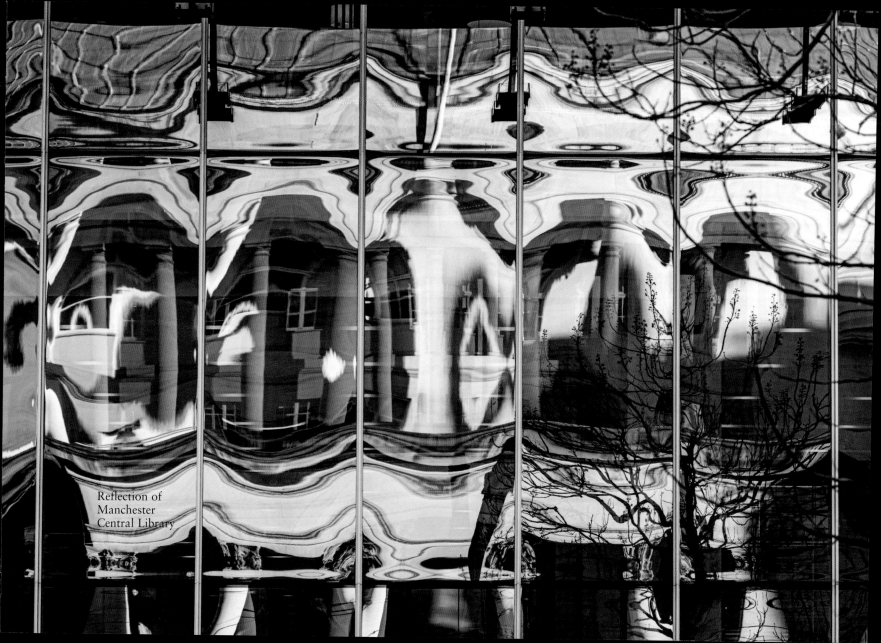

Reflection of
Manchester
Central Library

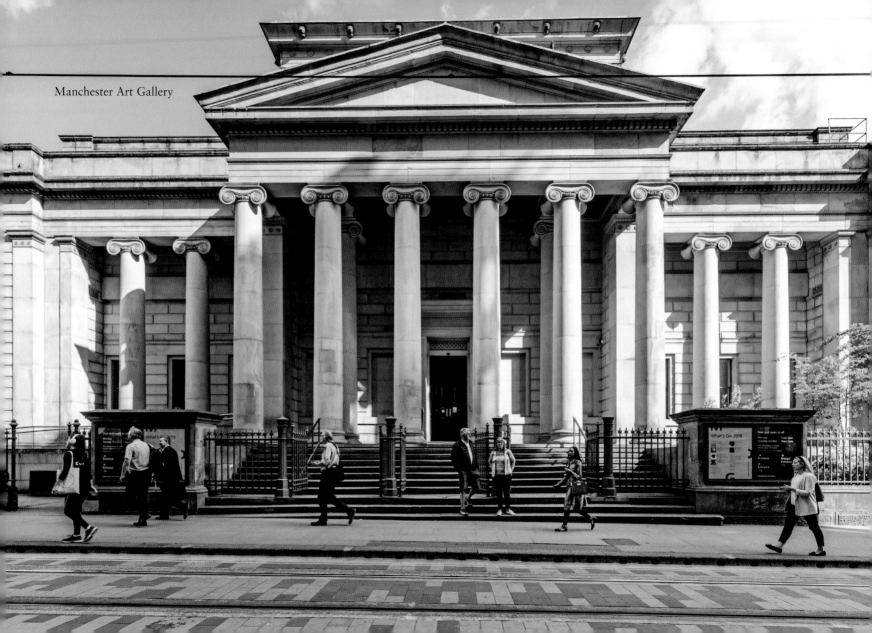

Manchester Art Gallery

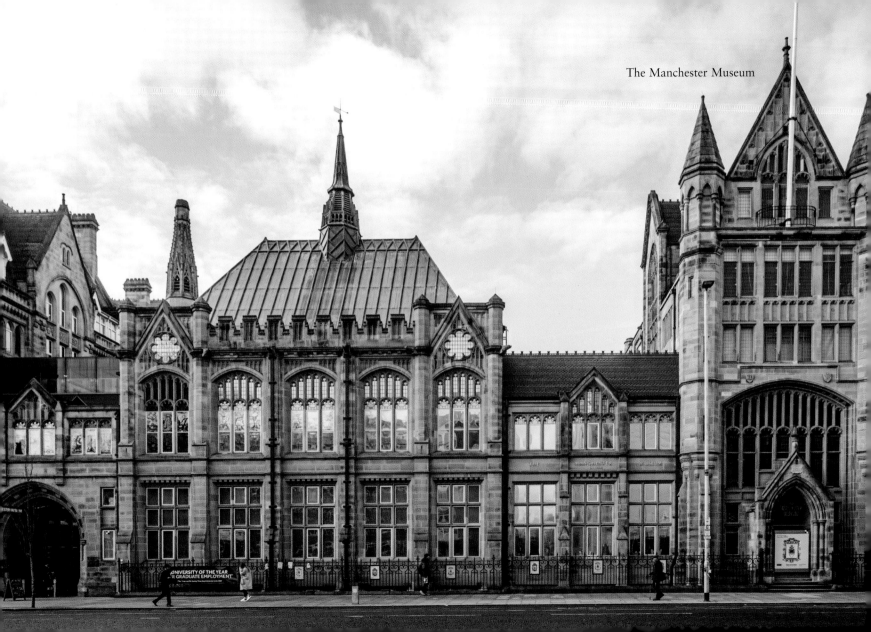

The Manchester Museum

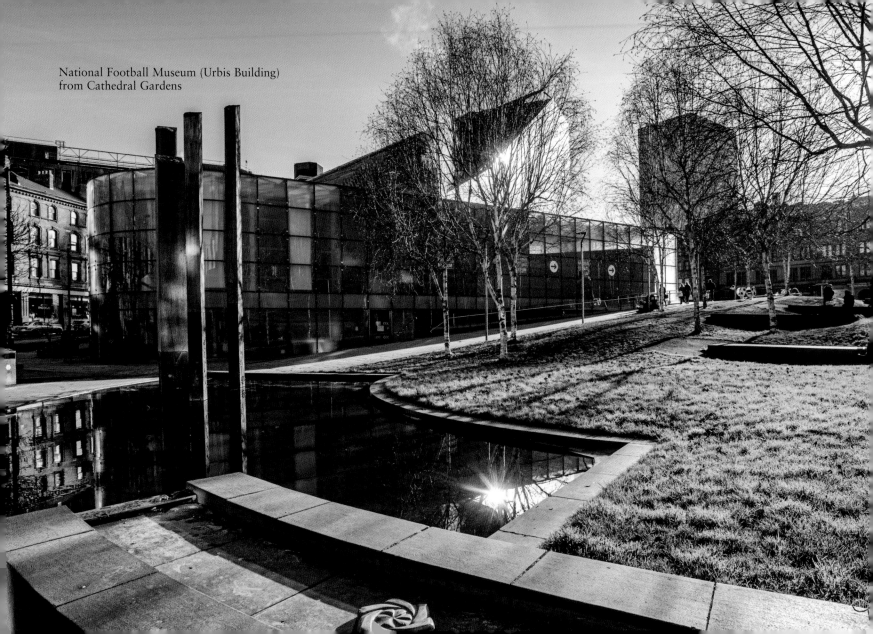

National Football Museum (Urbis Building)
from Cathedral Gardens

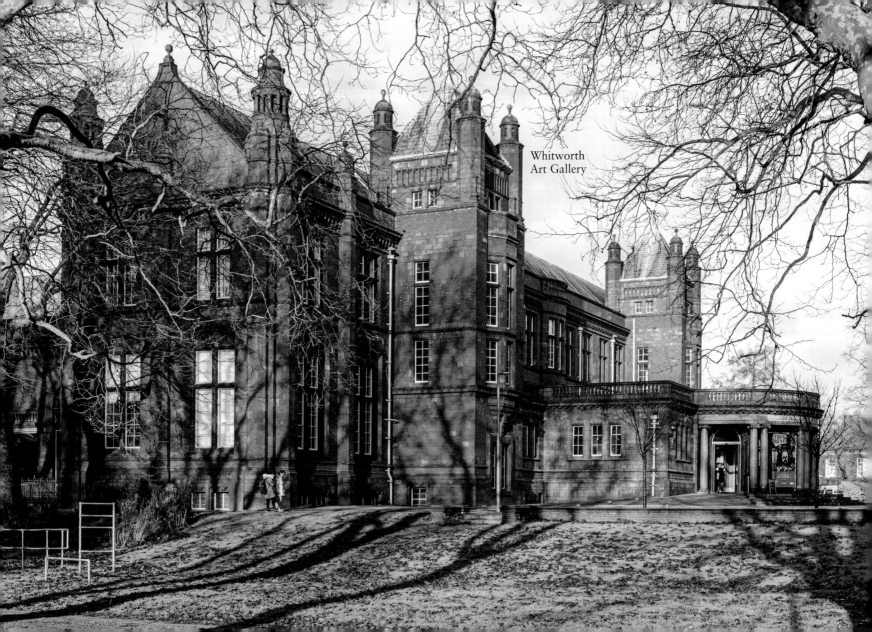

Whitworth
Art Gallery

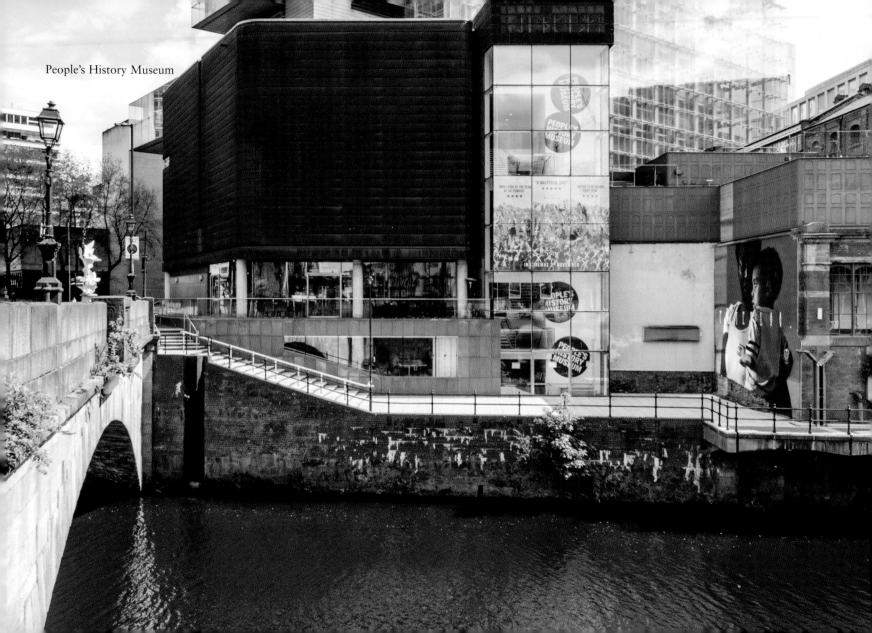

People's History Museum

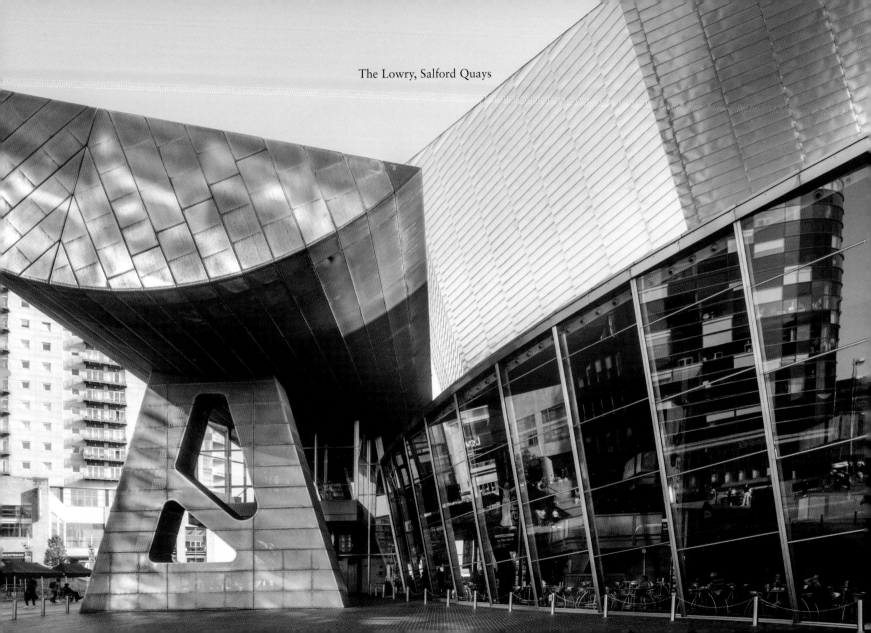

The Lowry, Salford Quays

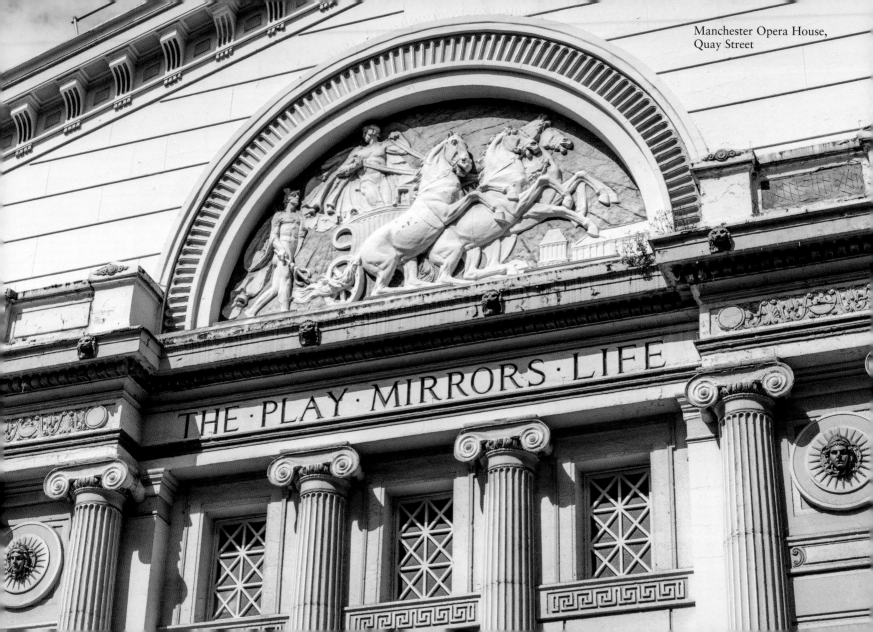

Manchester Opera House,
Quay Street

THE · PLAY · MIRRORS · LIFE

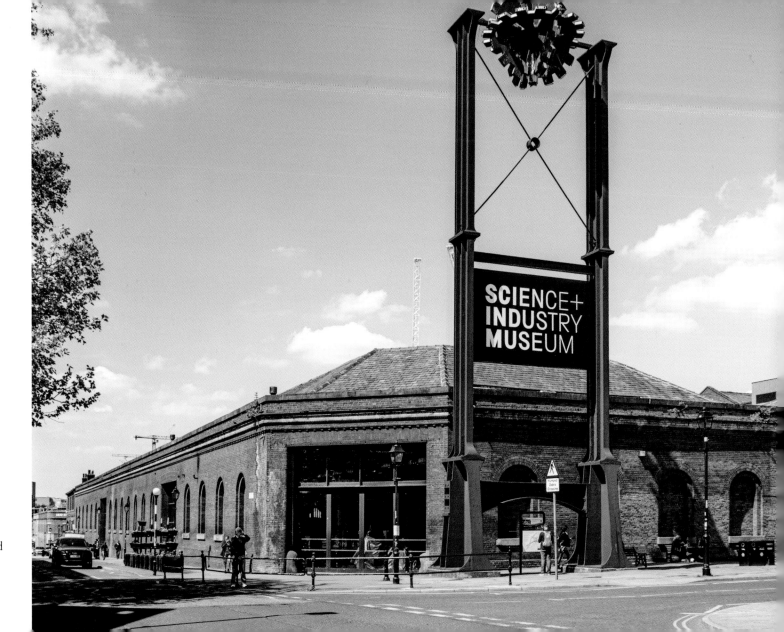

Science and
Industry
Museum,
London Road

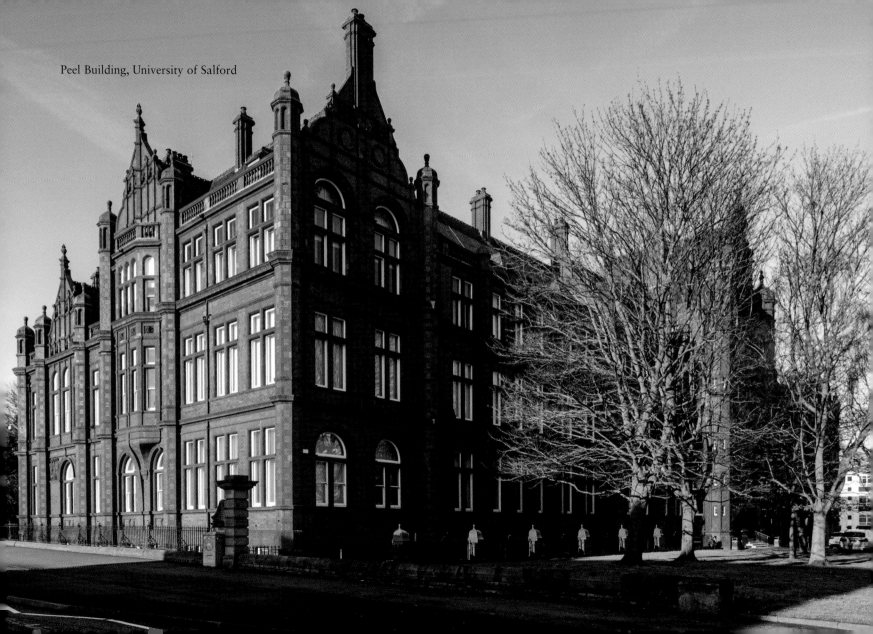

Peel Building, University of Salford

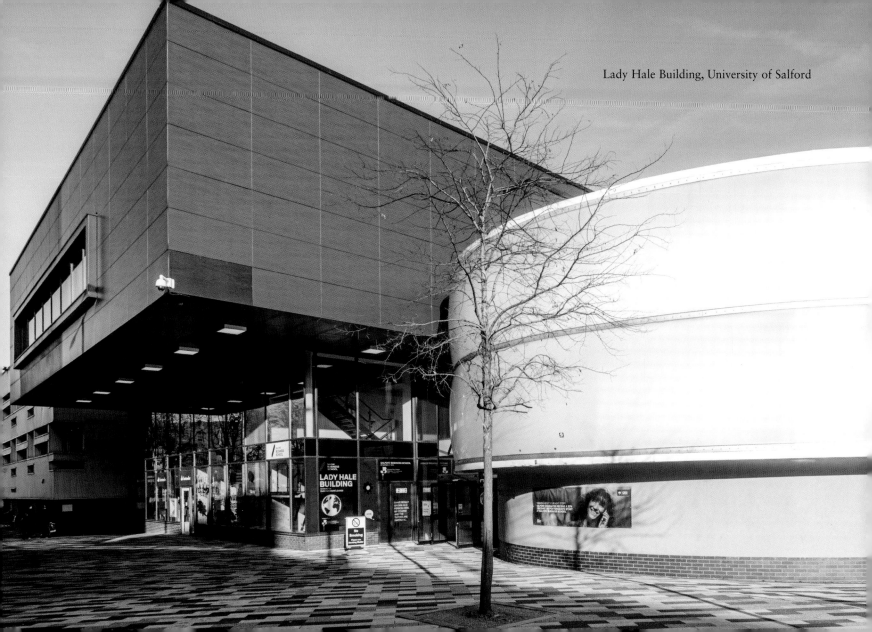
Lady Hale Building, University of Salford

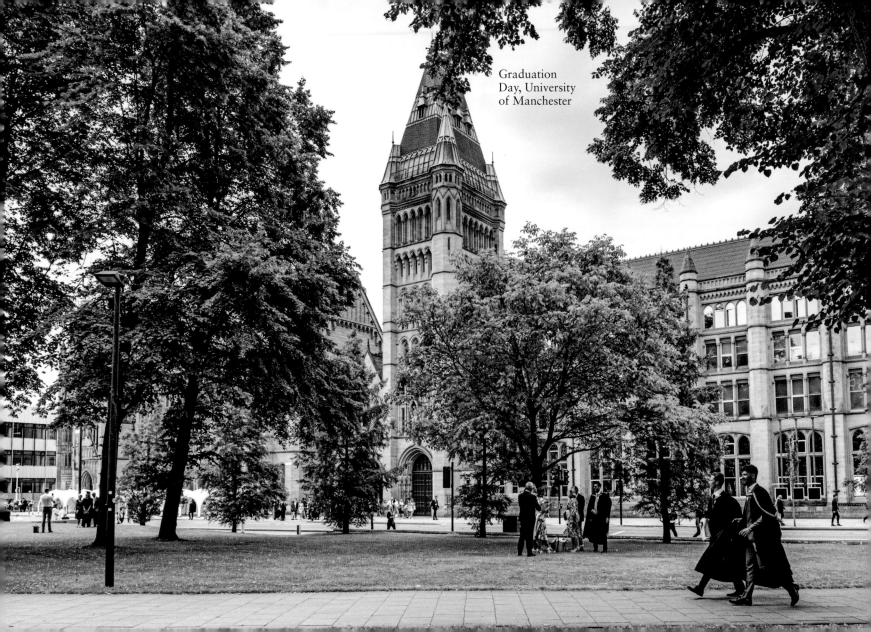

Graduation Day, University of Manchester

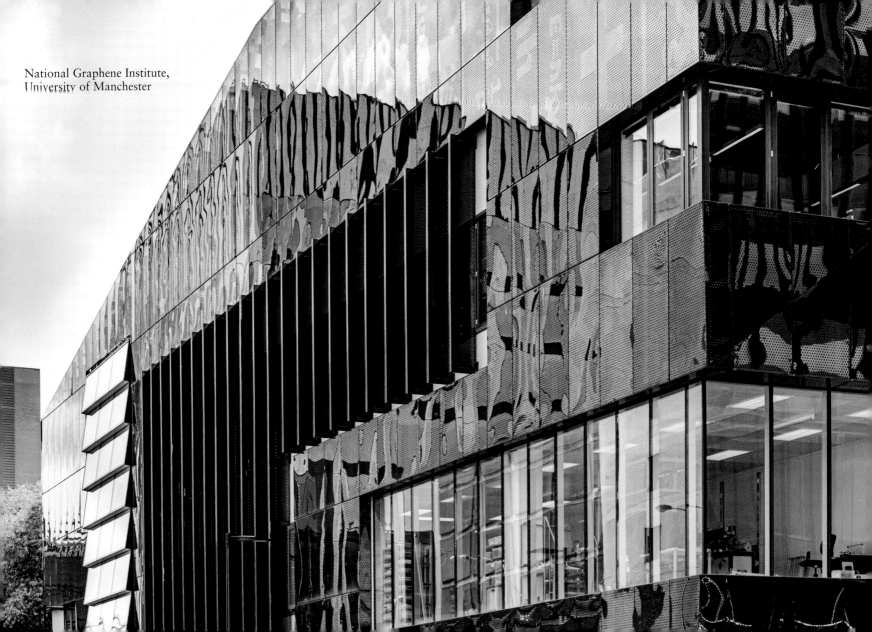

National Graphene Institute,
University of Manchester

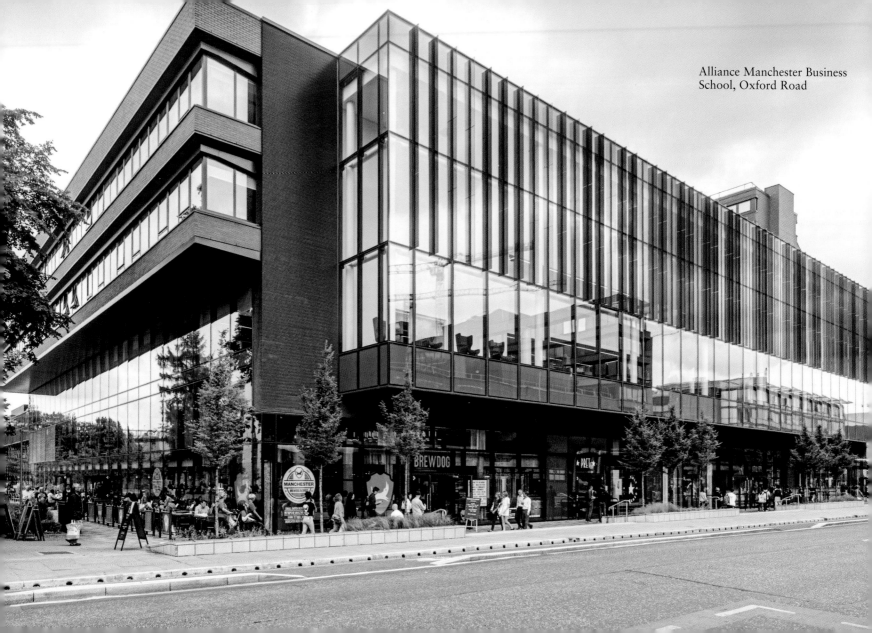

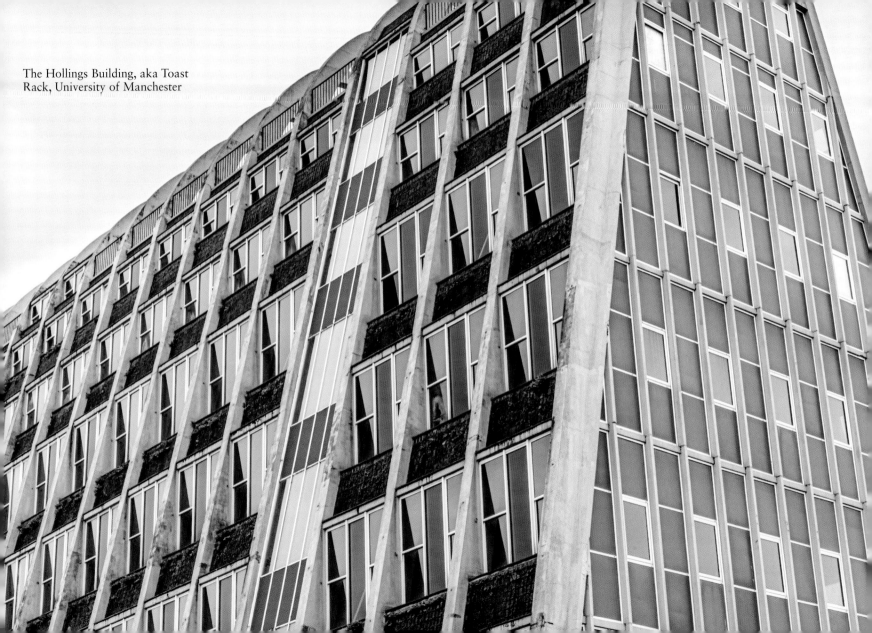

The Hollings Building, aka Toast Rack, University of Manchester

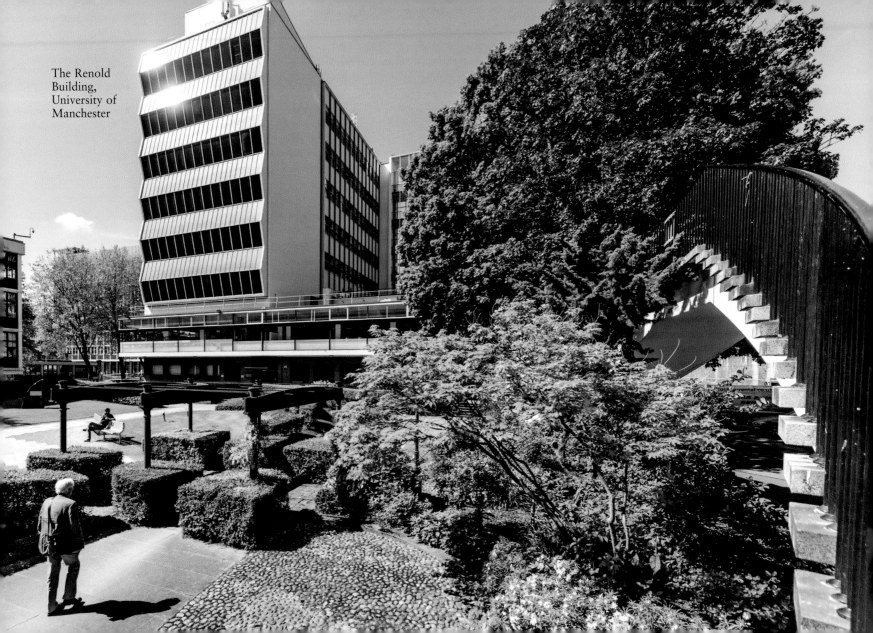

The Renold
Building,
University of
Manchester

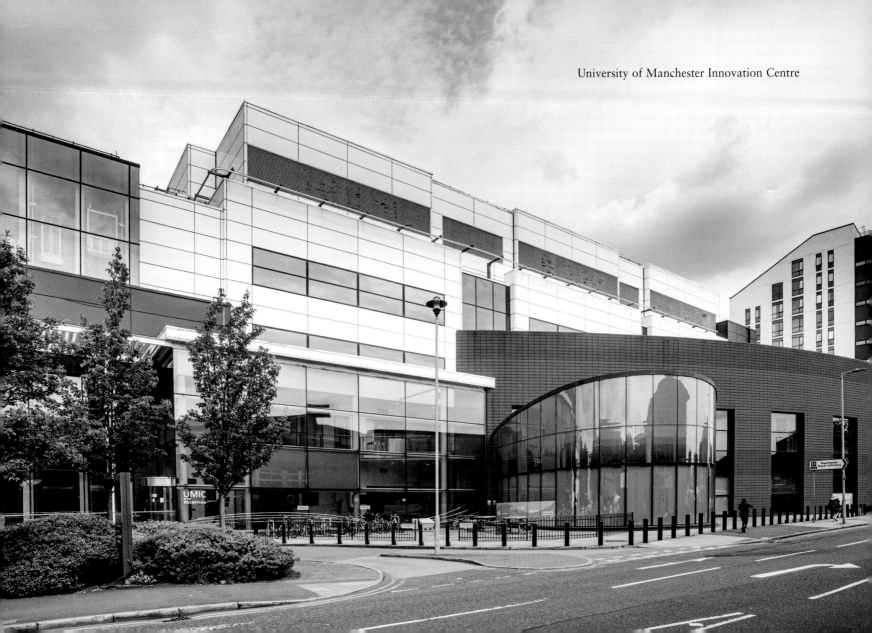

University of Manchester Innovation Centre

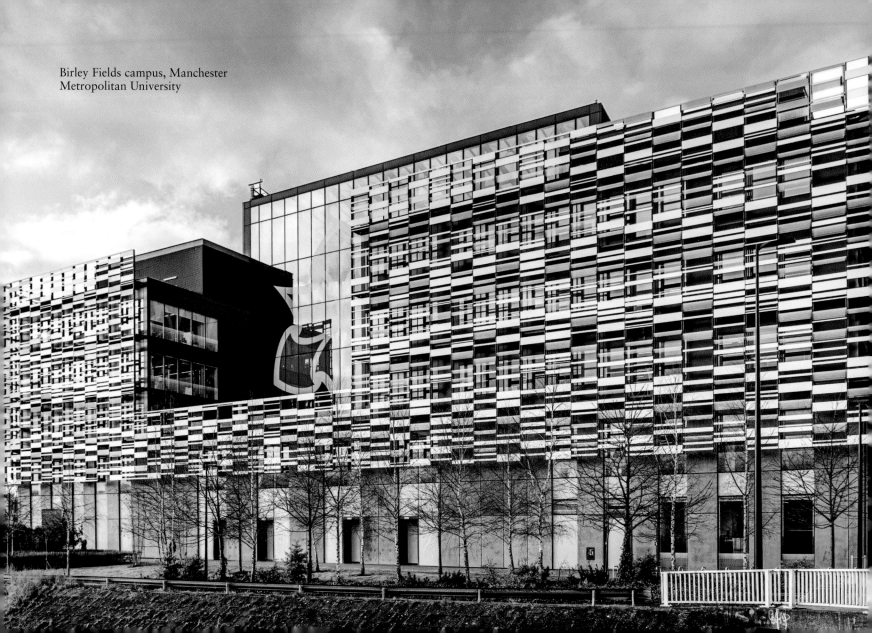

Birley Fields campus, Manchester
Metropolitan University

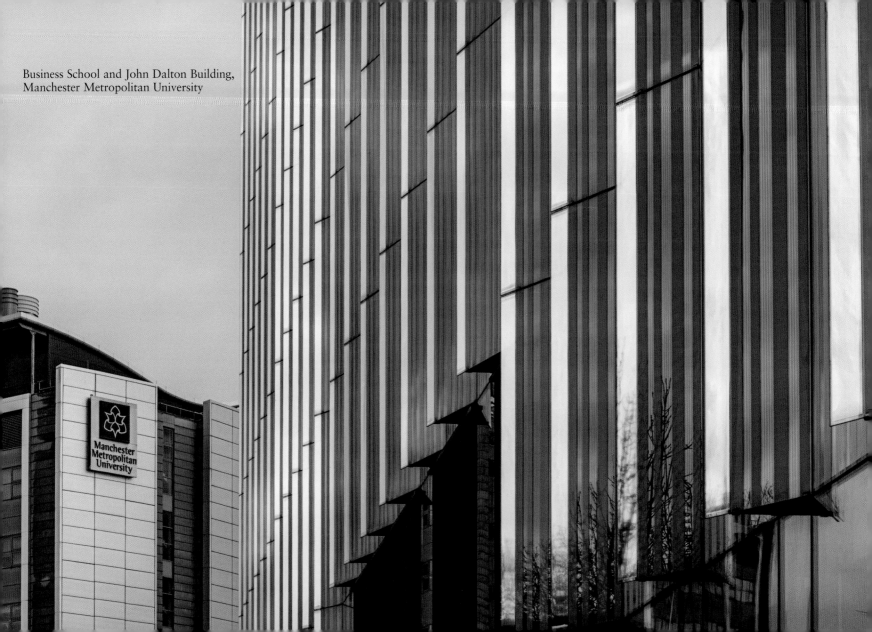

Business School and John Dalton Building,
Manchester Metropolitan University

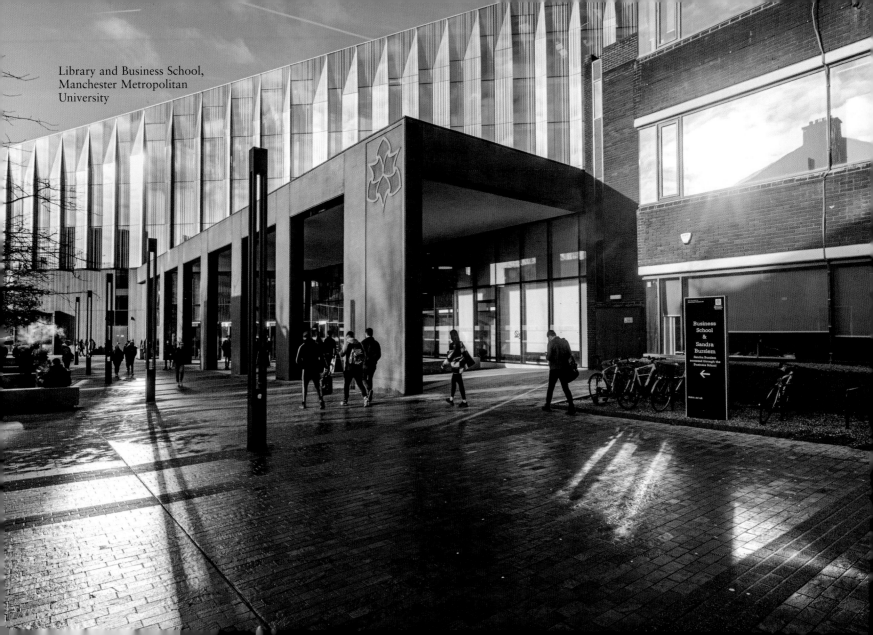

Library and Business School,
Manchester Metropolitan
University

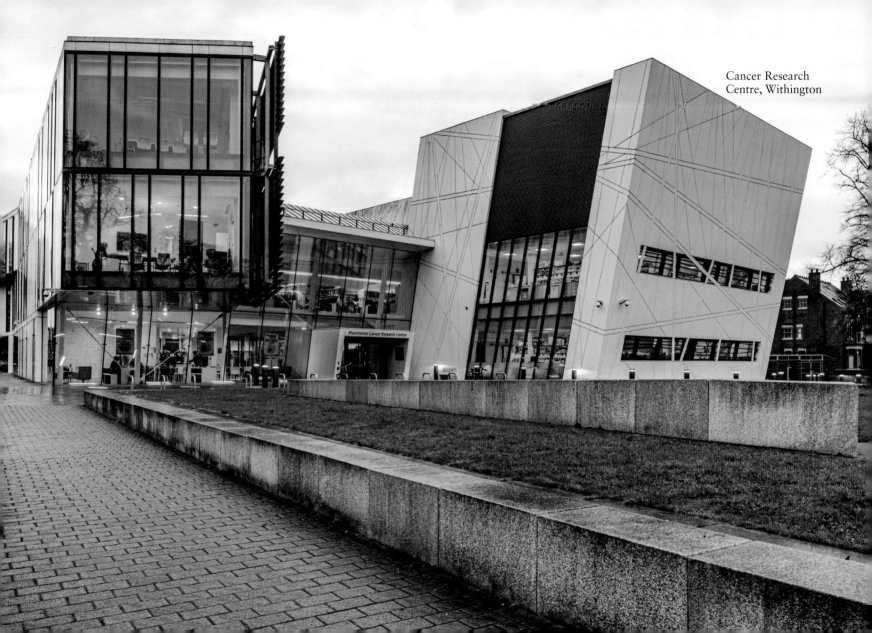
Cancer Research
Centre, Withington

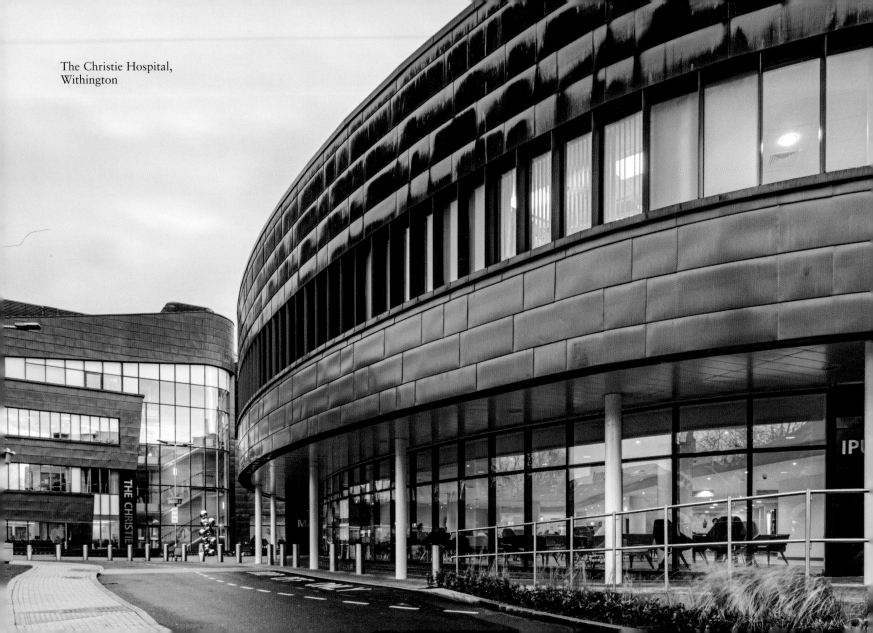

The Christie Hospital,
Withington

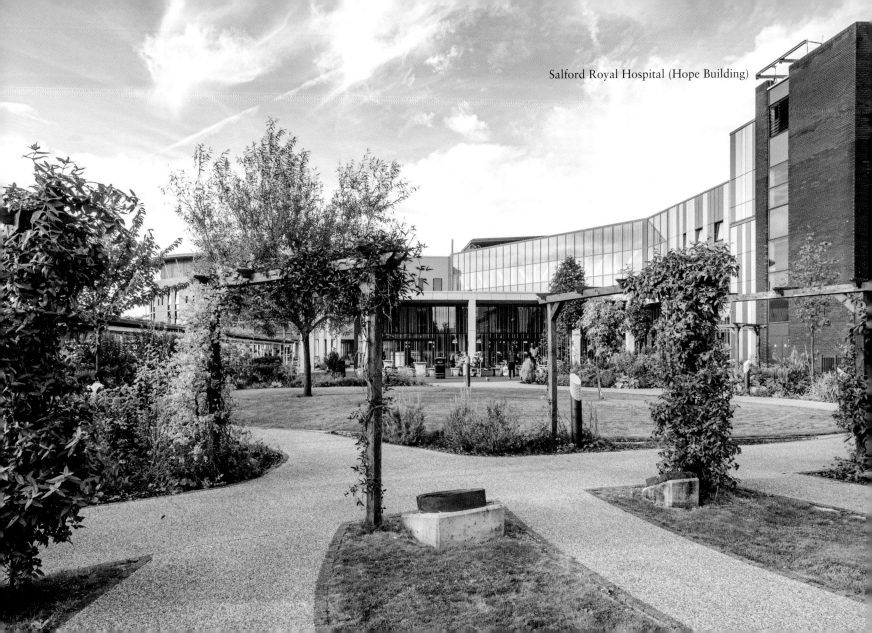

Salford Royal Hospital (Hope Building)

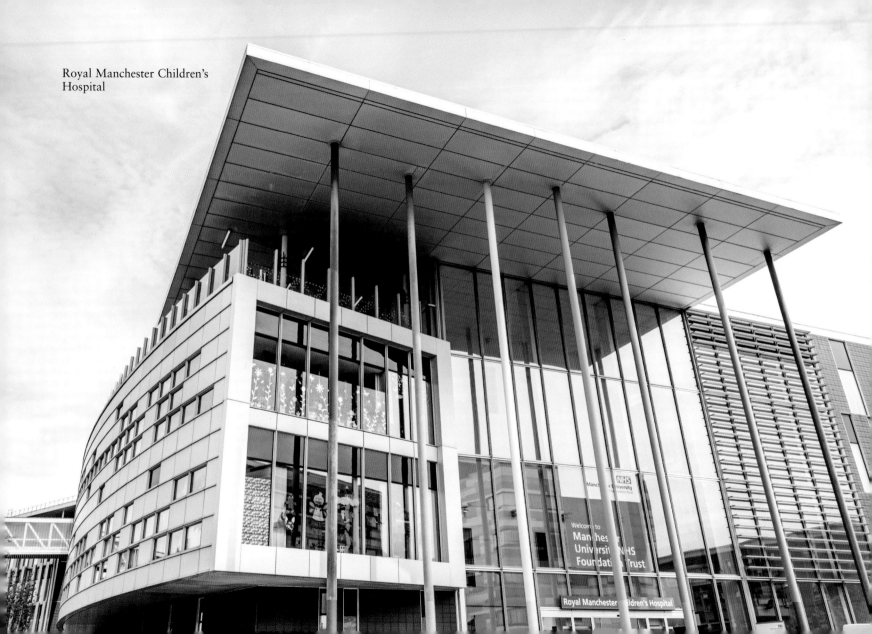

Royal Manchester Children's Hospital

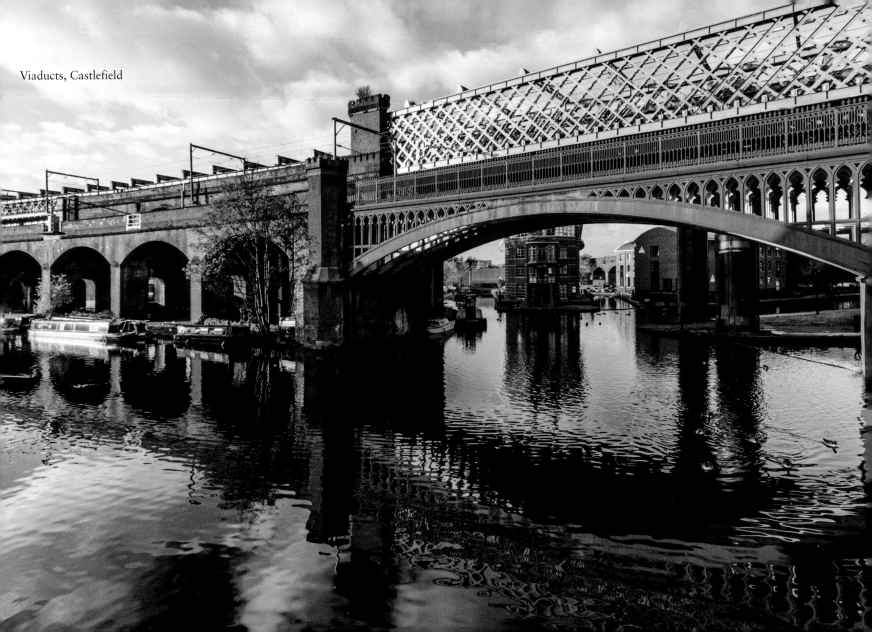

Viaducts, Castlefield

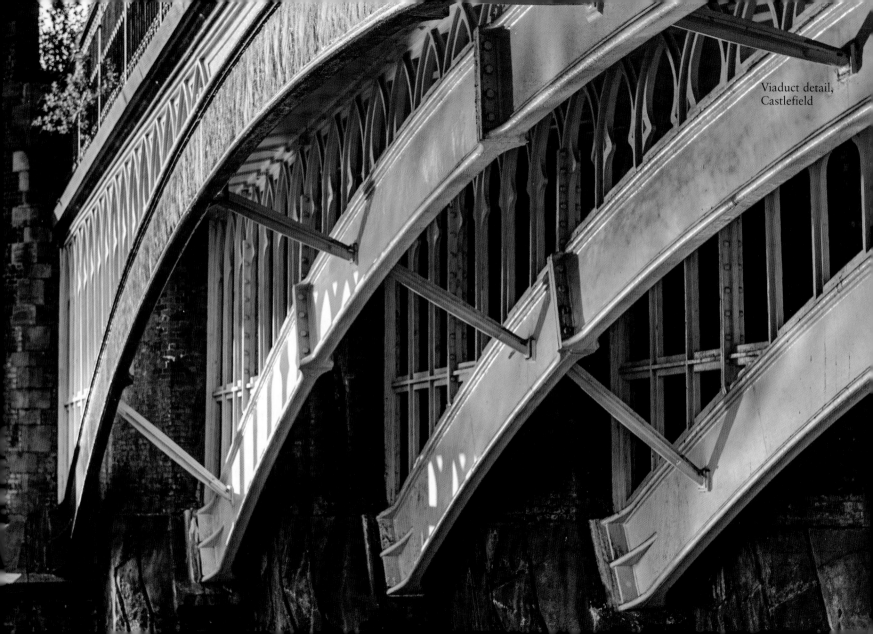

Viaduct detail,
Castlefield

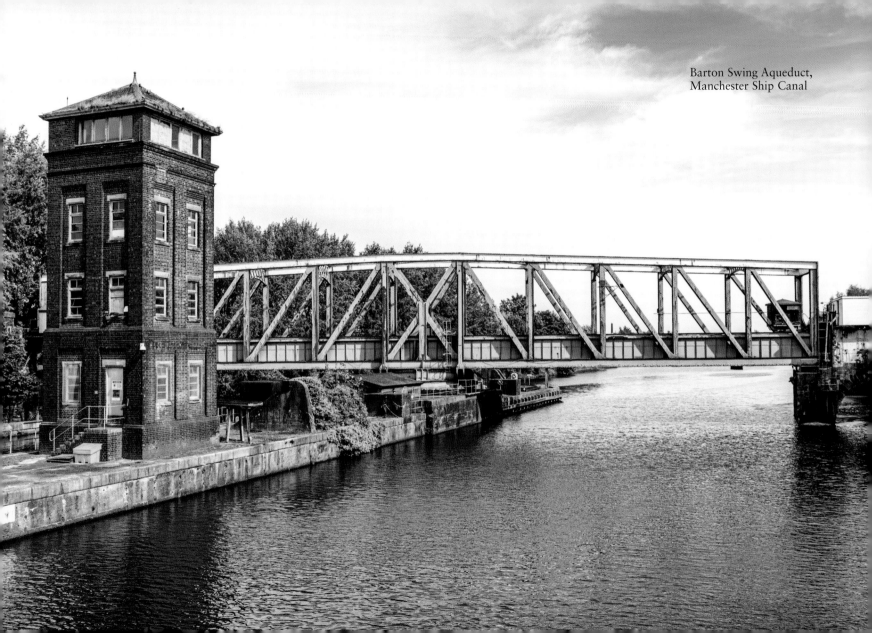

Barton Swing Aqueduct,
Manchester Ship Canal

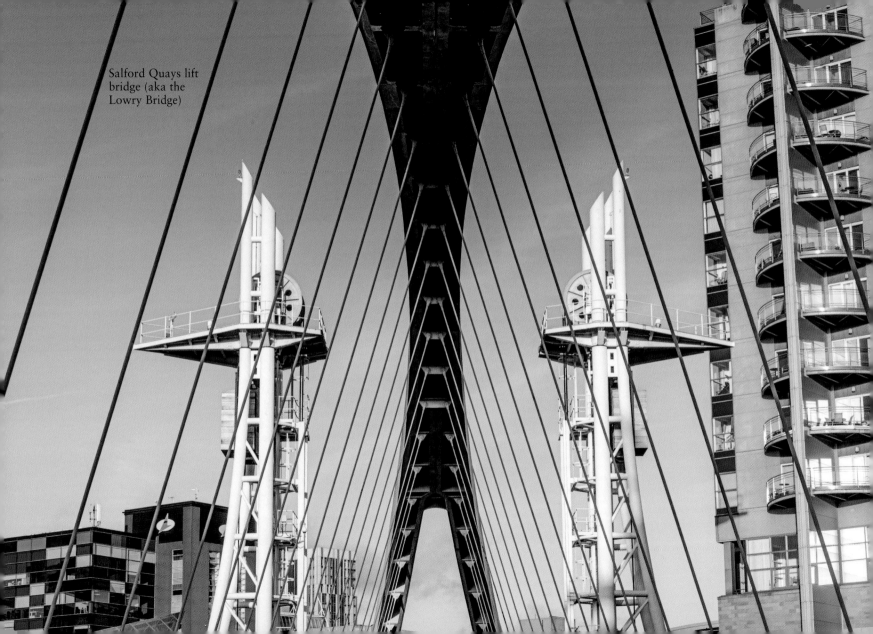

Salford Quays lift
bridge (aka the
Lowry Bridge)

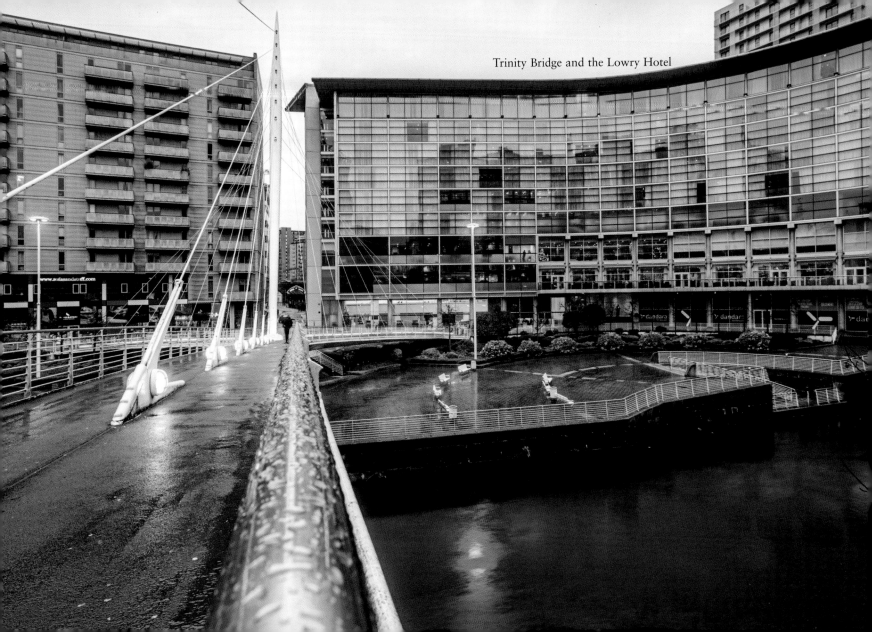

Trinity Bridge and the Lowry Hotel

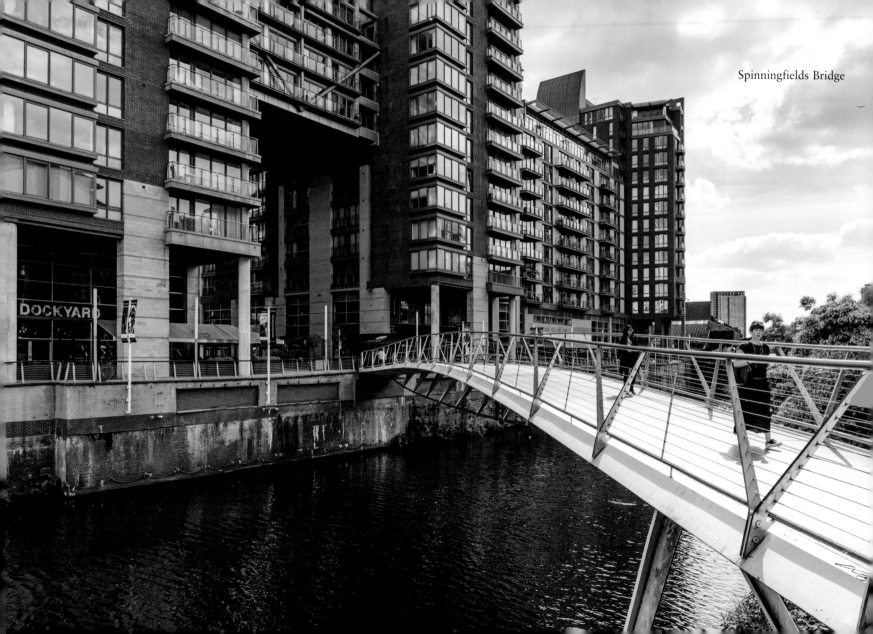

Spinningfields Bridge

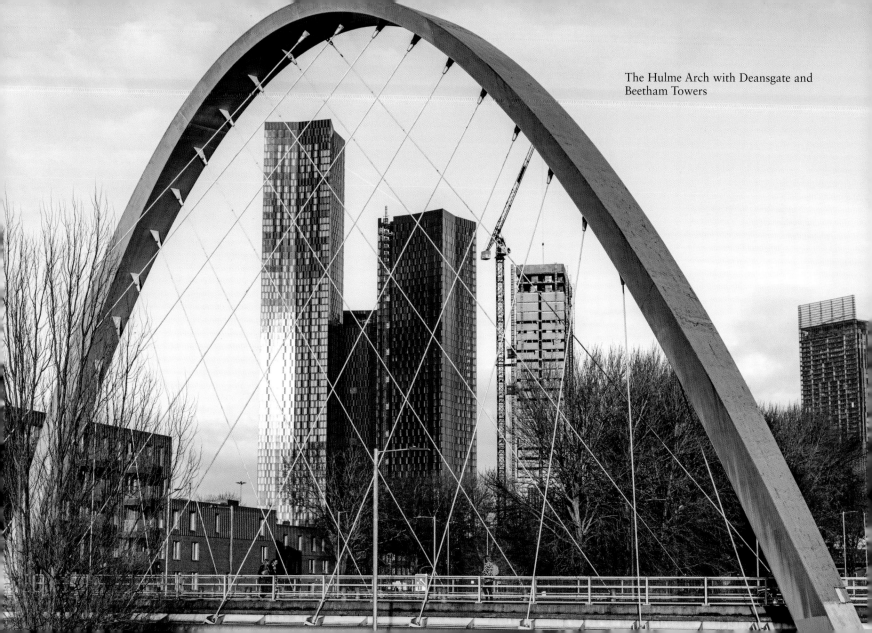

The Hulme Arch with Deansgate and Beetham Towers

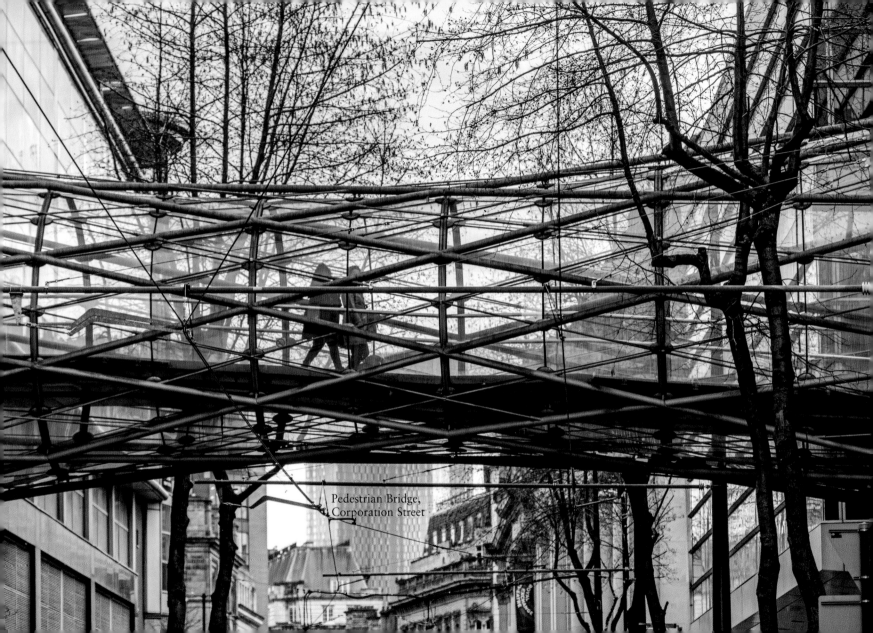

Pedestrian Bridge,
Corporation Street

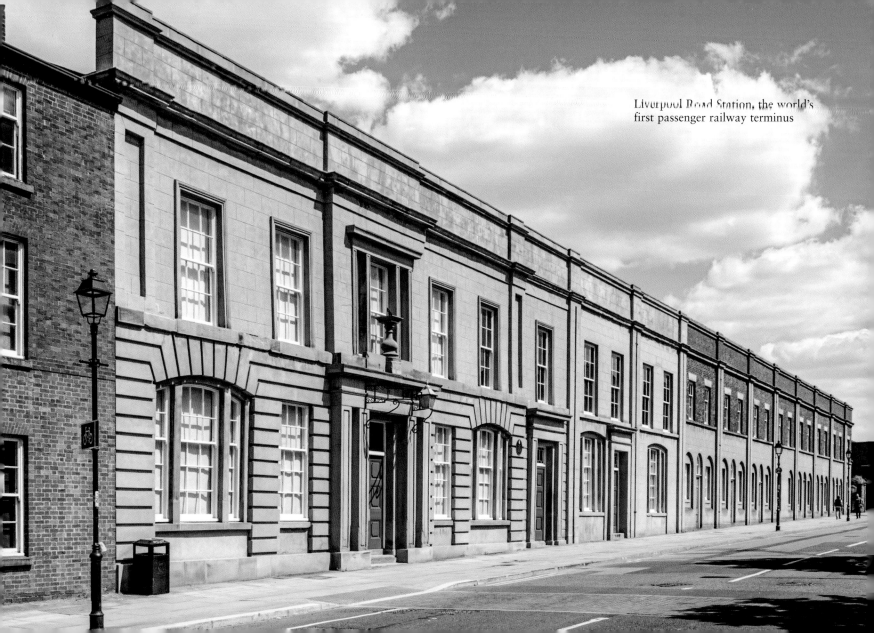
Liverpool Road Station, the world's first passenger railway terminus

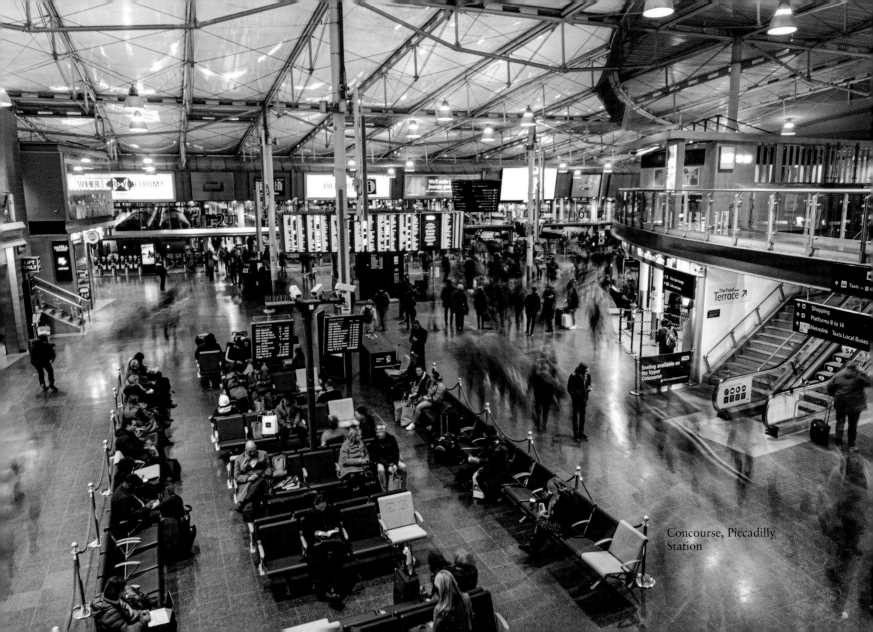

Concourse, Piccadilly Station

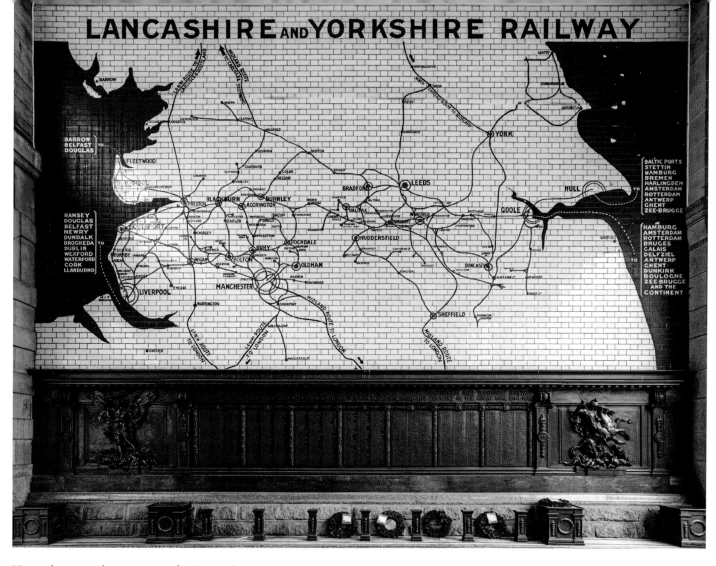

Network map and war memorial, Victoria Station

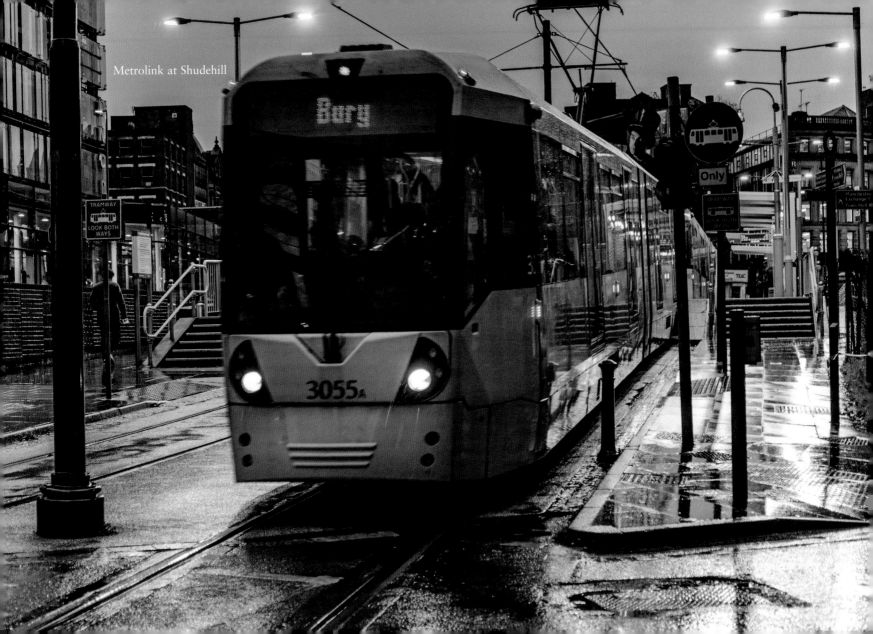

Metrolink at Shudehill

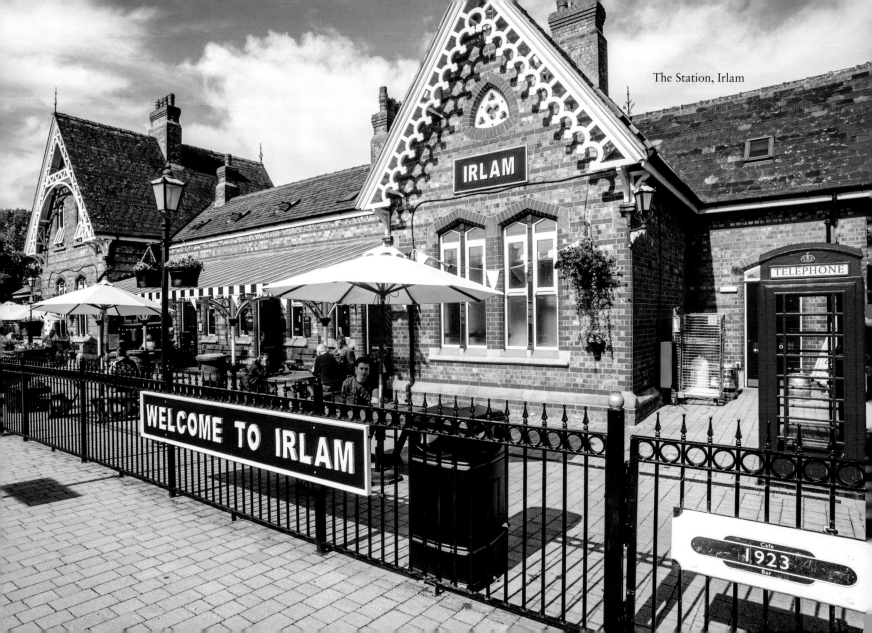

The Station, Irlam

IRLAM

TELEPHONE

WELCOME TO IRLAM

Cafe
1923
Bar

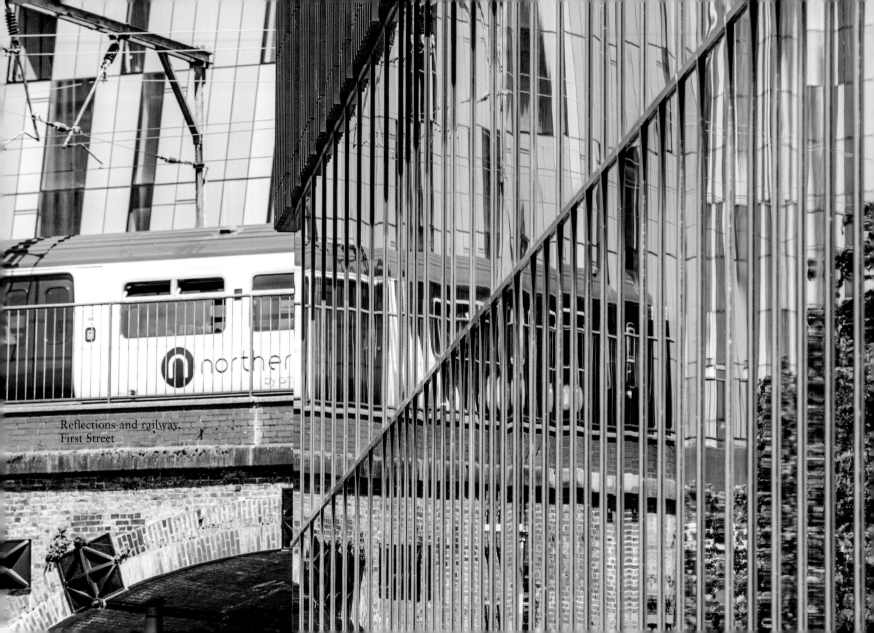

Reflections and railway,
First Street

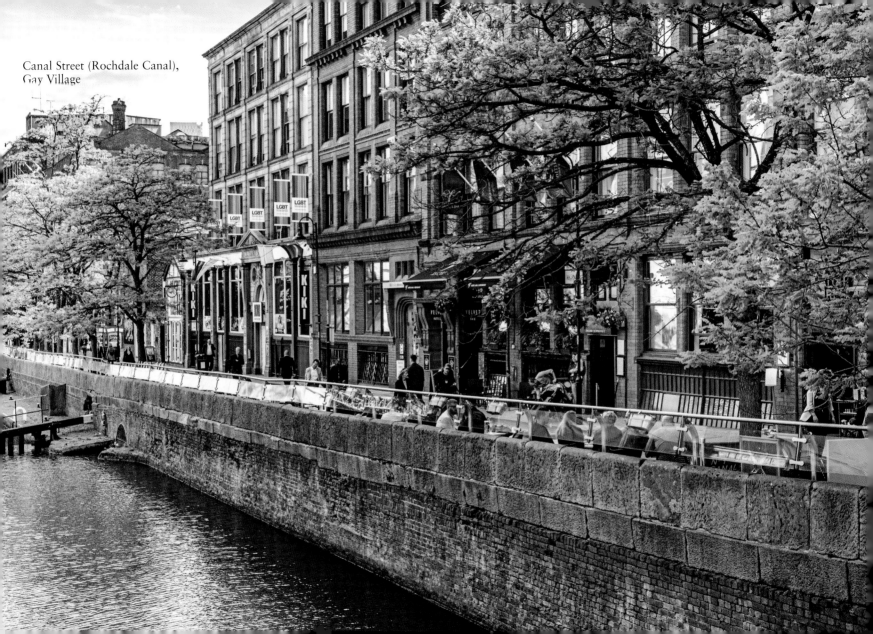

Canal Street (Rochdale Canal),
Gay Village

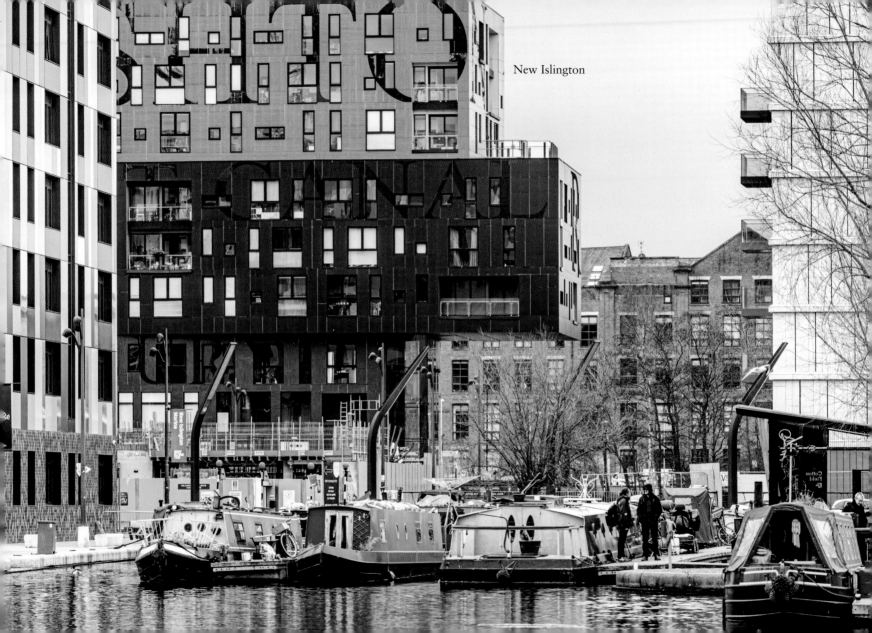

New Islington

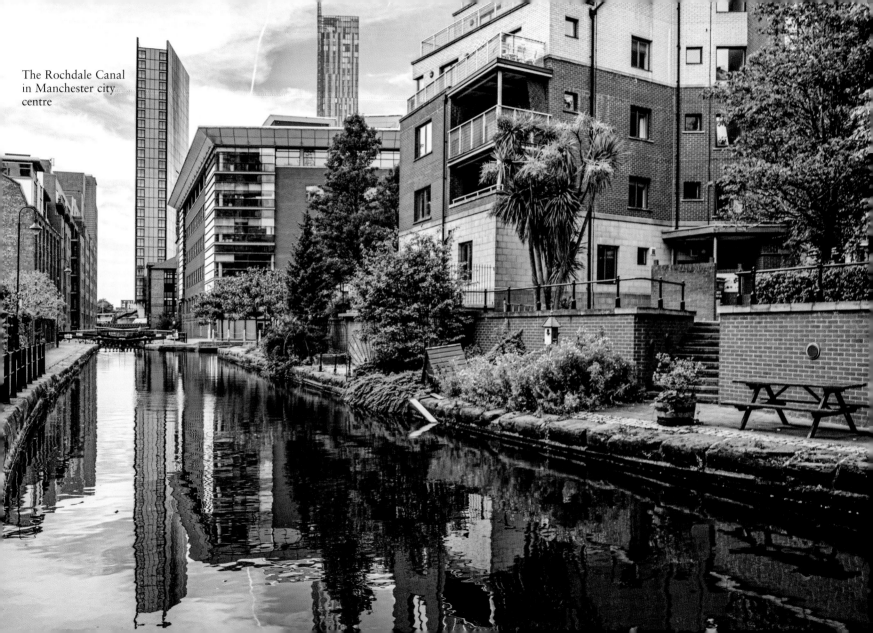

The Rochdale Canal in Manchester city centre

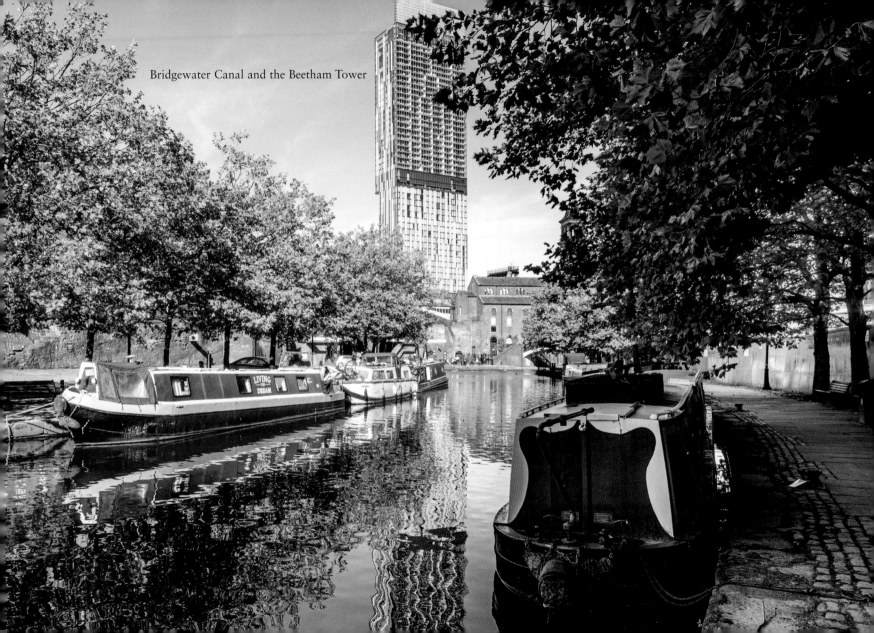

Bridgewater Canal and the Beetham Tower

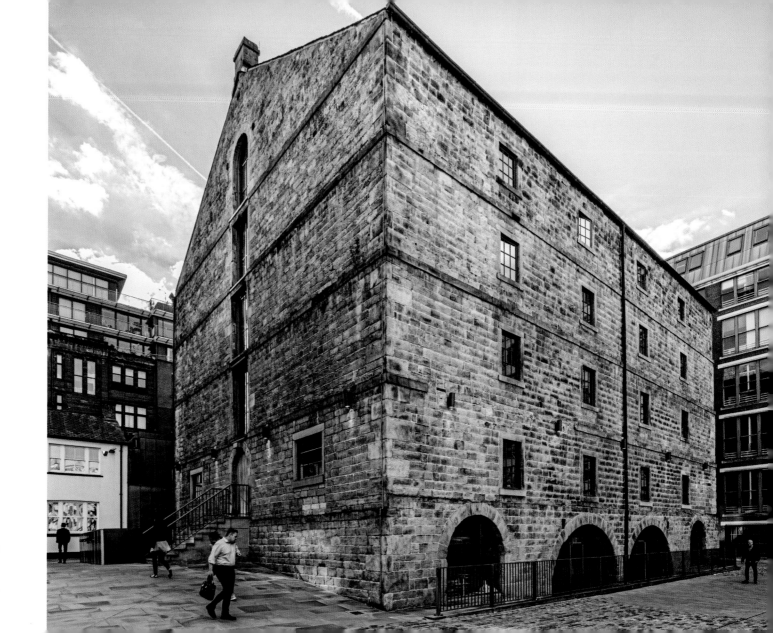

Dale Street
Warehouse,
Piccadilly Basin

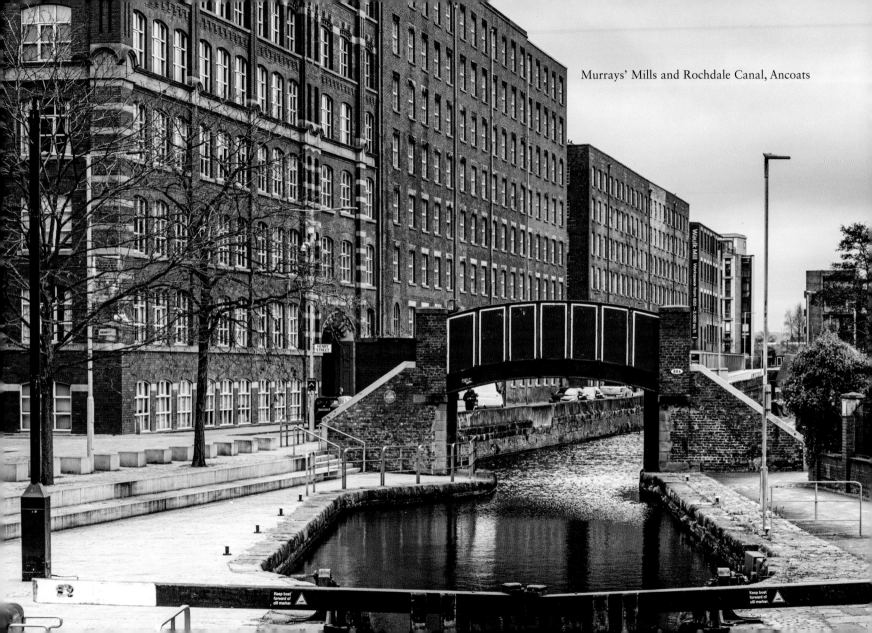

Murrays' Mills and Rochdale Canal, Ancoats

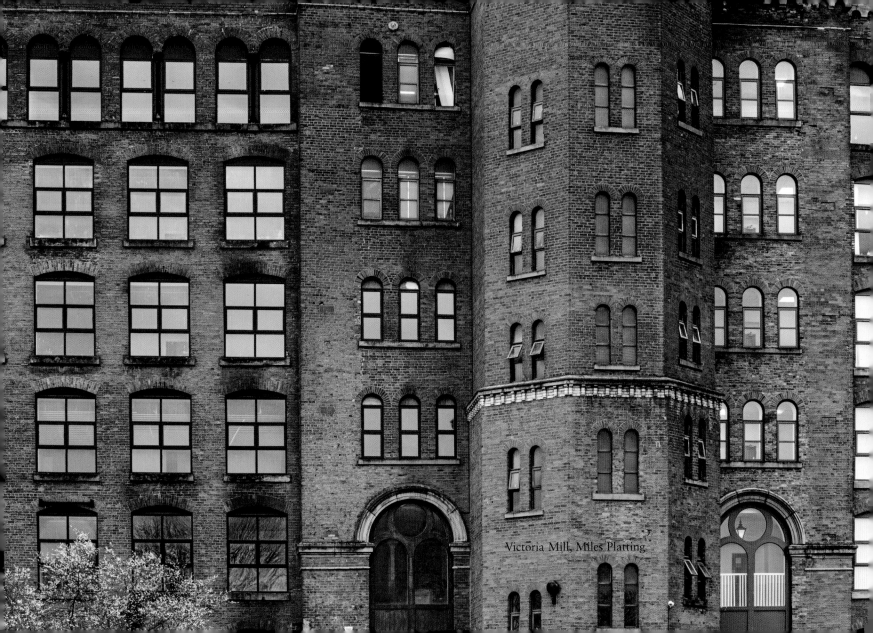

Victoria Mill, Miles Platting

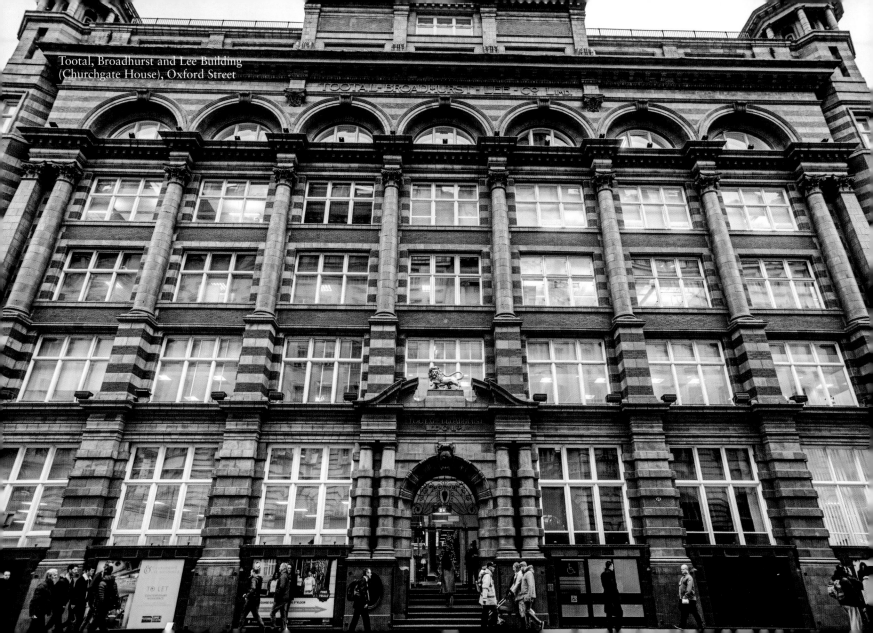

Tootal, Broadhurst and Lee Building
(Churchgate House), Oxford Street

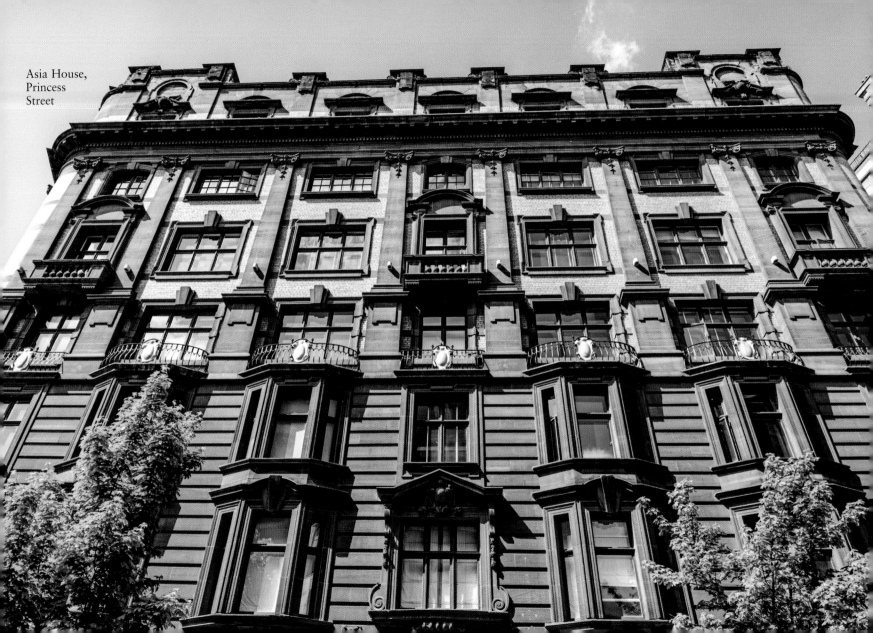

Asia House,
Princess
Street

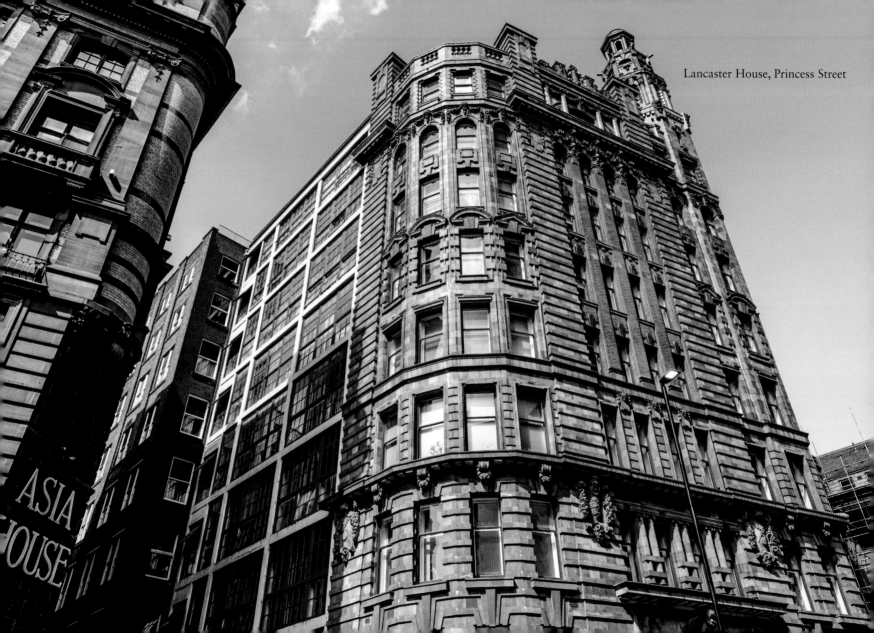

Lancaster House, Princess Street

ASIA
HOUSE

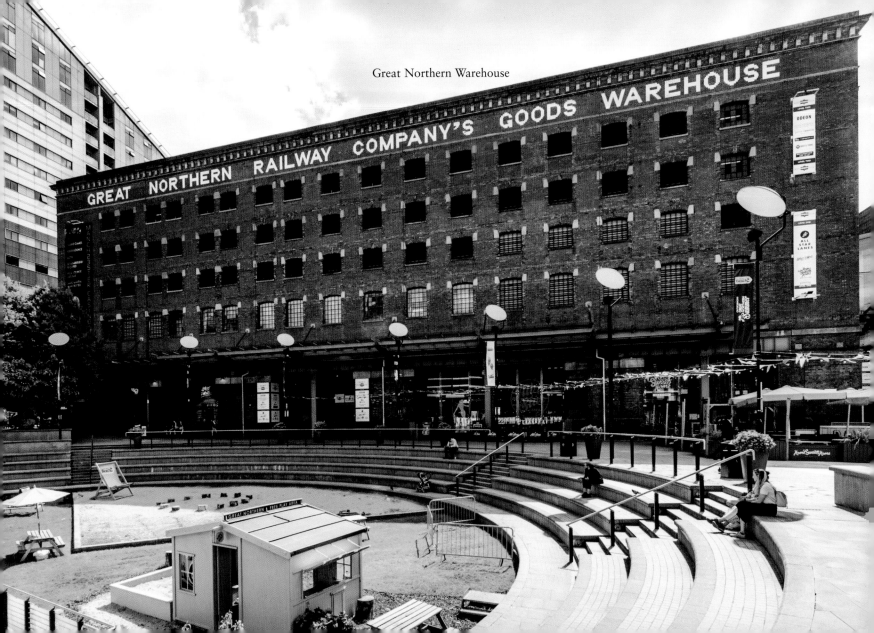

Great Northern Warehouse

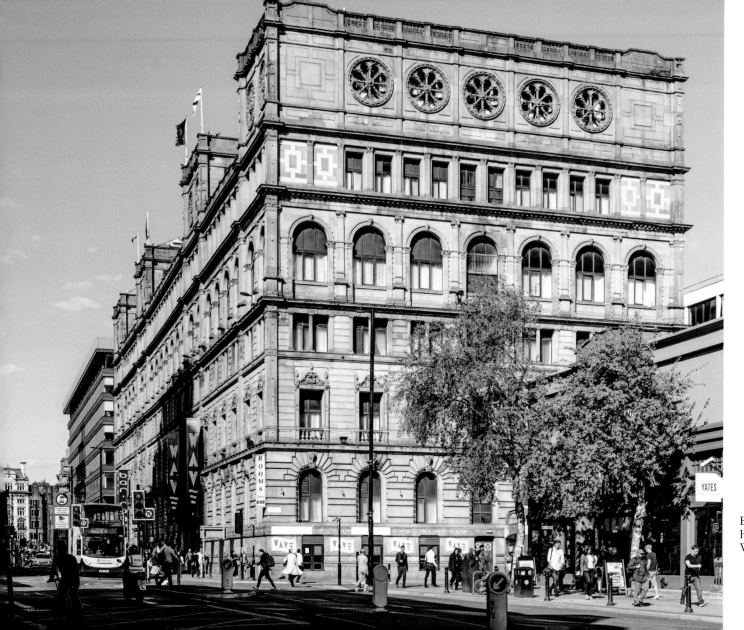

Britannia Manchester
Hotel (originally
Watts Warehouse)

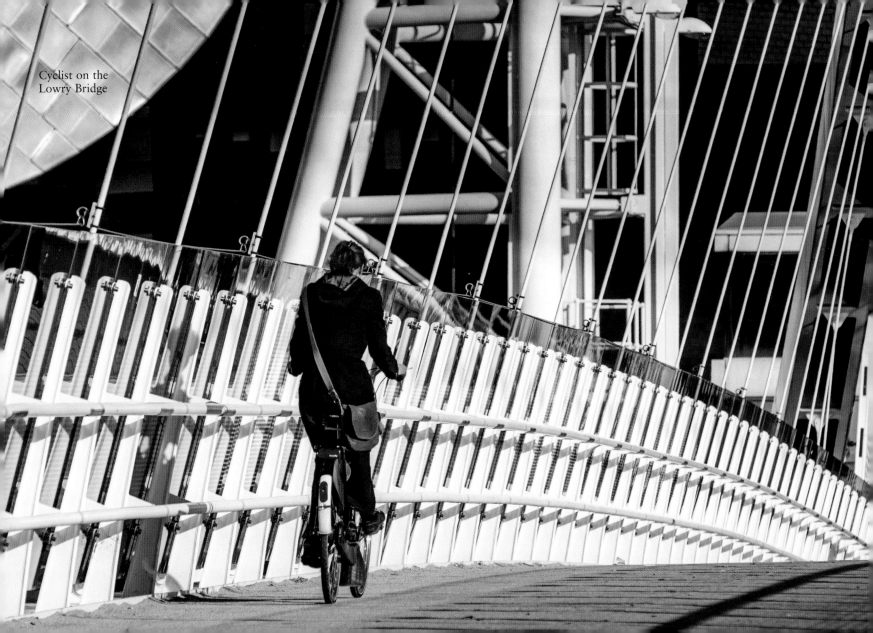
Cyclist on the
Lowry Bridge

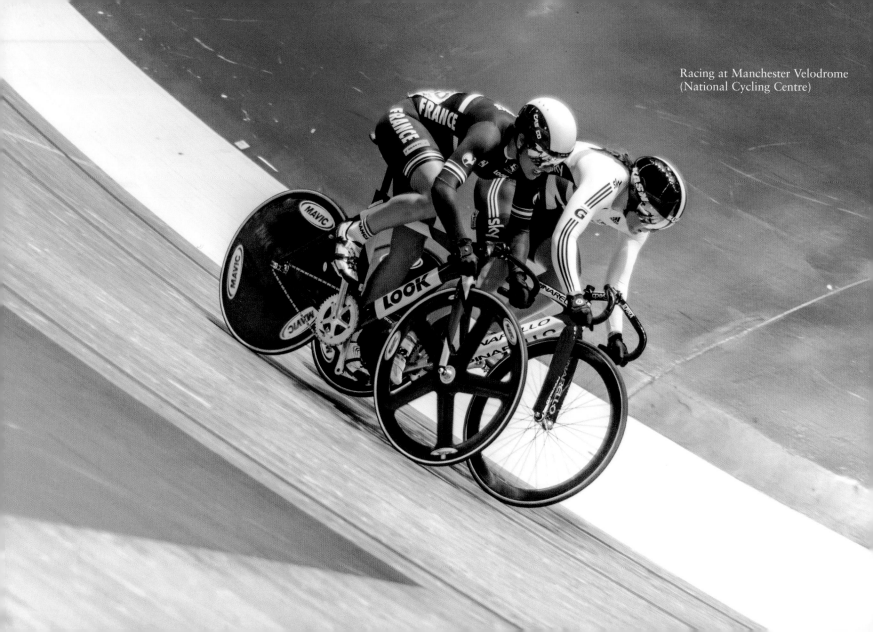

Racing at Manchester Velodrome
(National Cycling Centre)

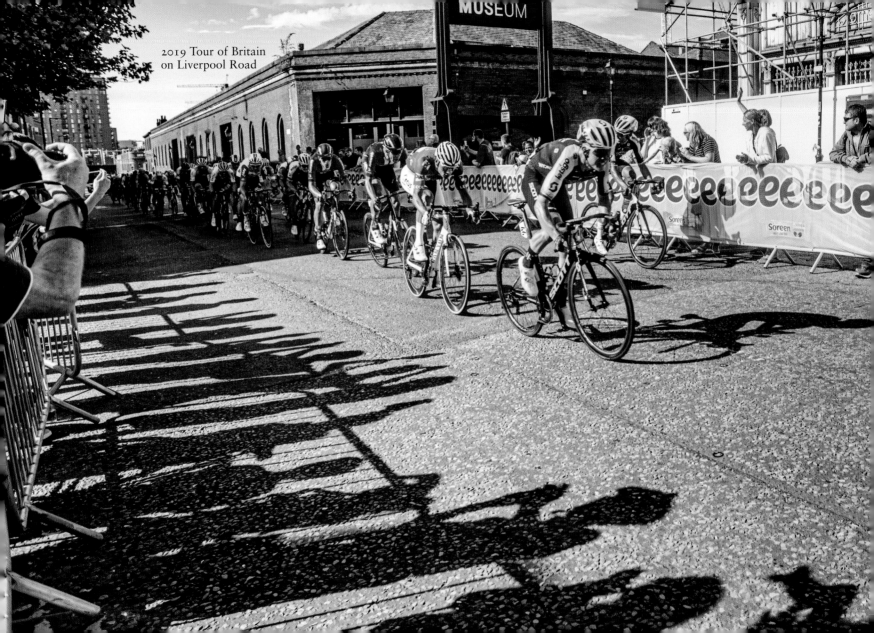

2019 Tour of Britain
on Liverpool Road

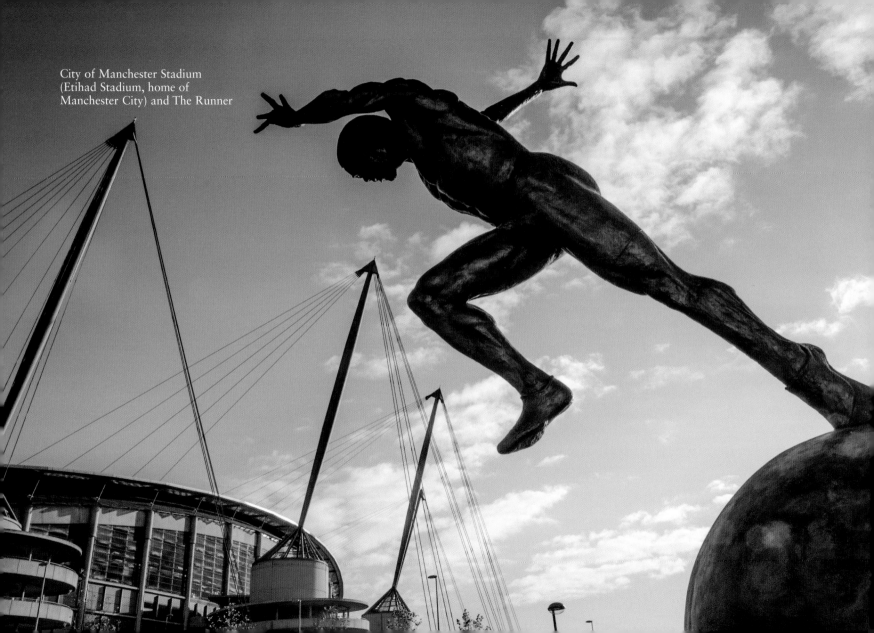

City of Manchester Stadium
(Etihad Stadium, home of
Manchester City) and The Runner

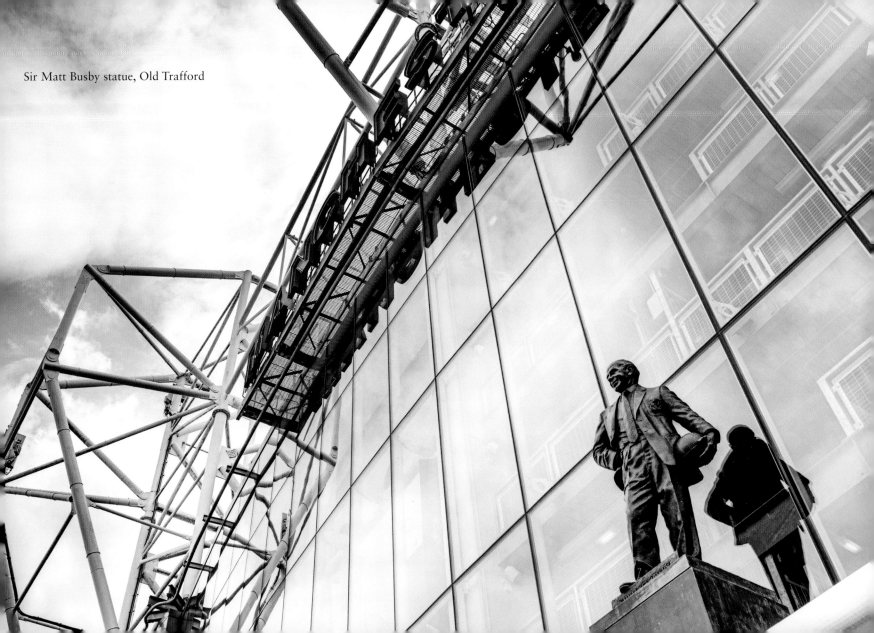

Sir Matt Busby statue, Old Trafford

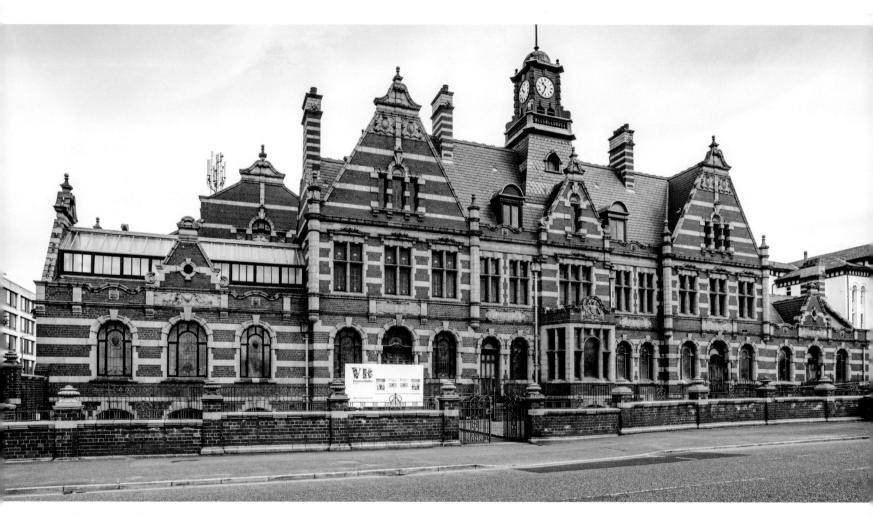

Victoria Baths

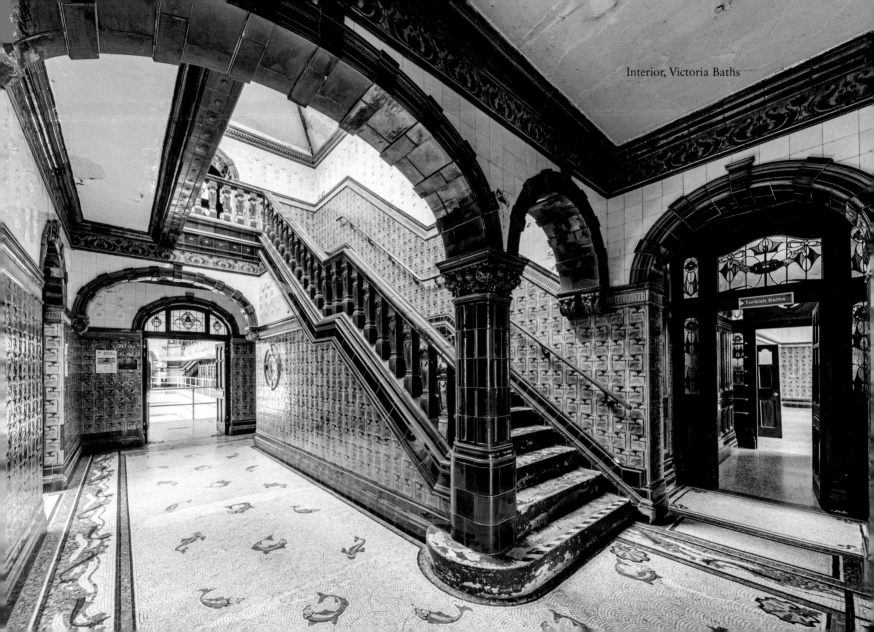

Interior, Victoria Baths

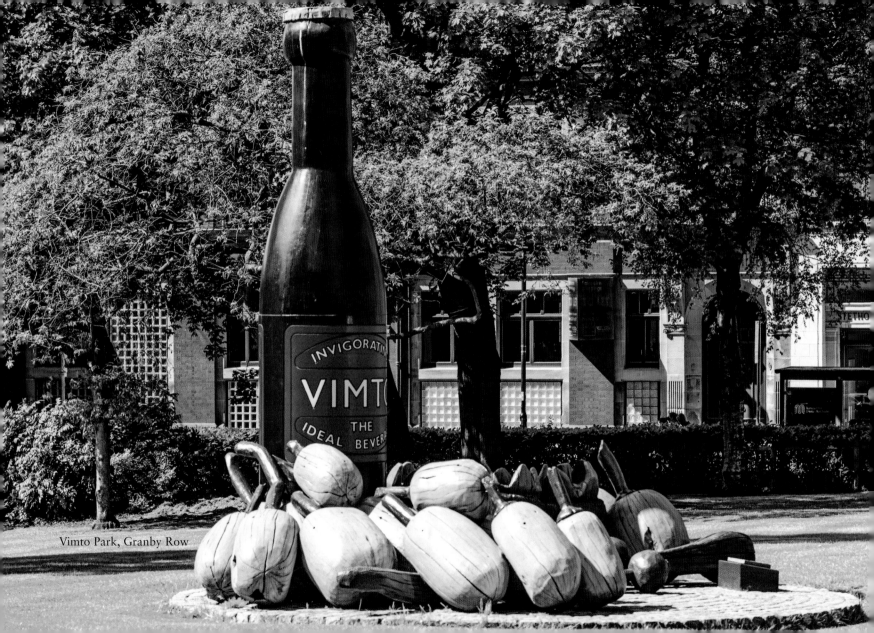

Vimto Park, Granby Row

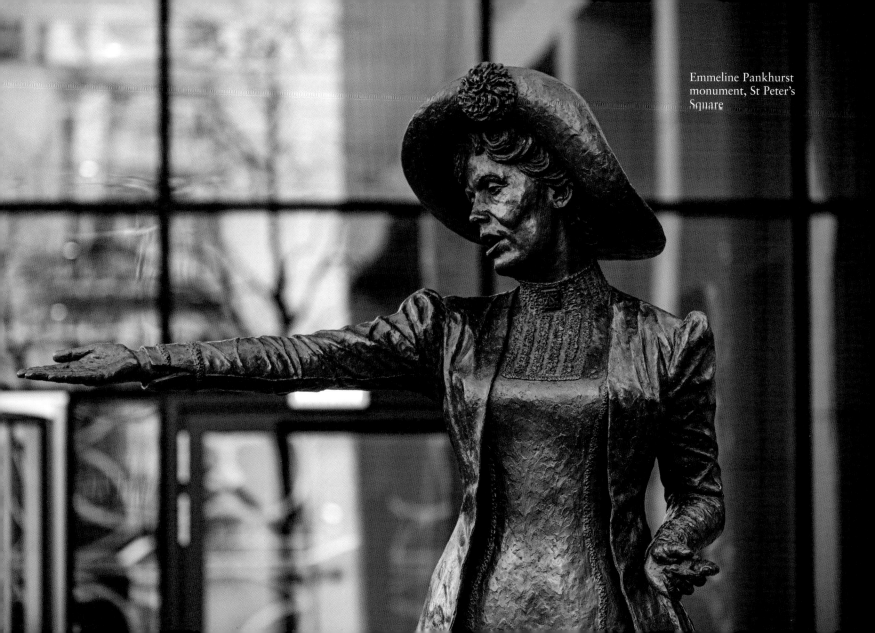

Emmeline Pankhurst
monument, St Peter's
Square

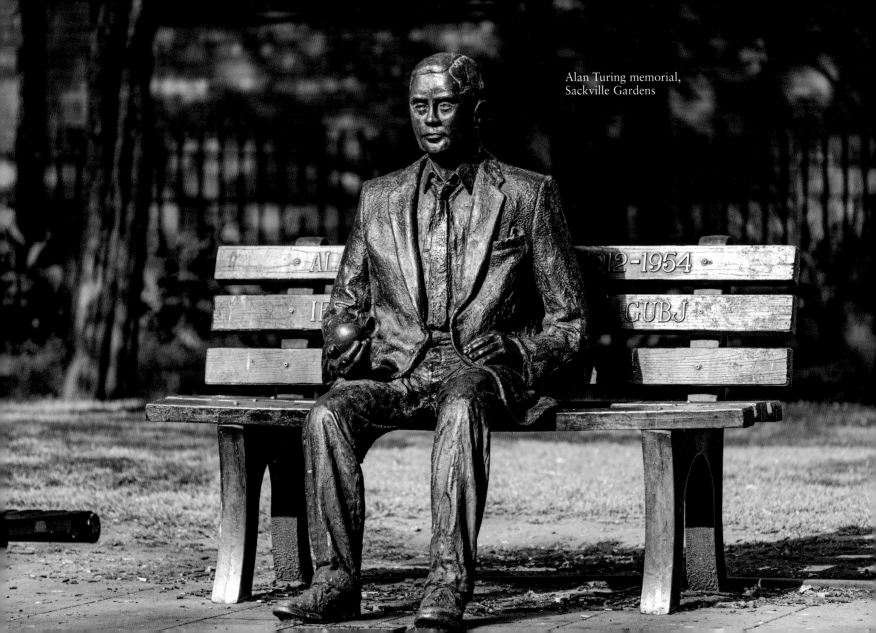

Alan Turing memorial,
Sackville Gardens

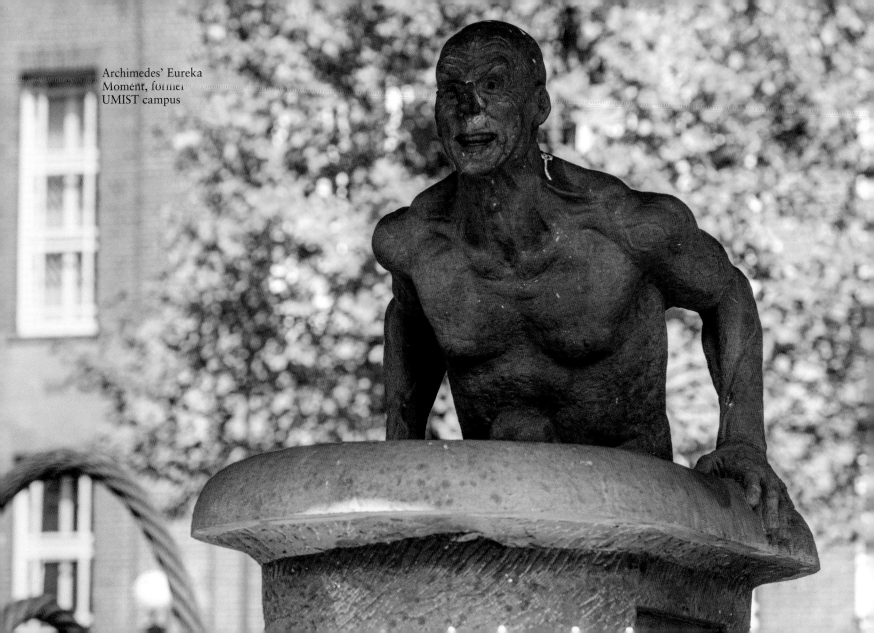

Archimedes' Eureka
Moment, former
UMIST campus

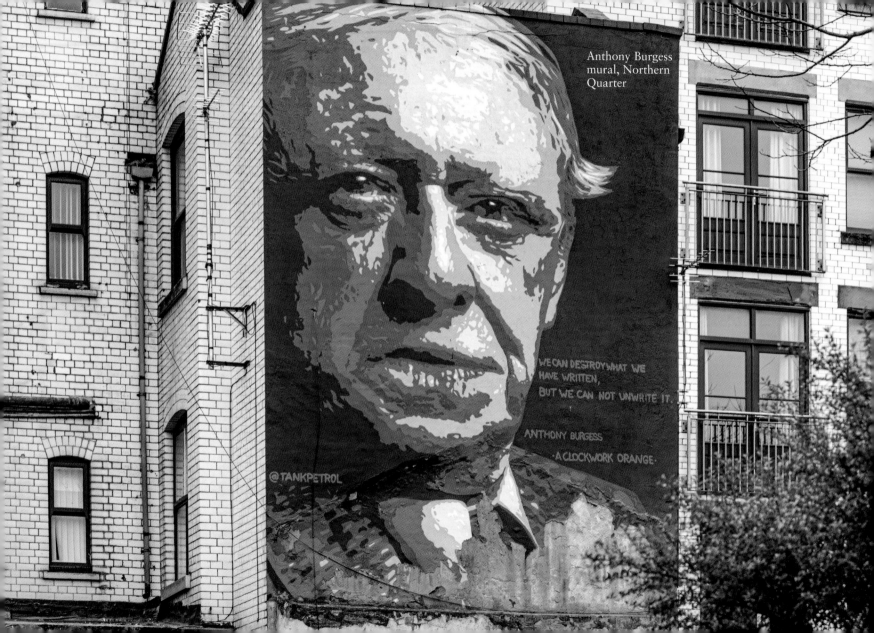

Anthony Burgess mural, Northern Quarter

WE CAN DESTROY WHAT WE HAVE WRITTEN, BUT WE CAN NOT UNWRITE IT.

ANTHONY BURGESS

A CLOCKWORK ORANGE.

@TANKPETROL

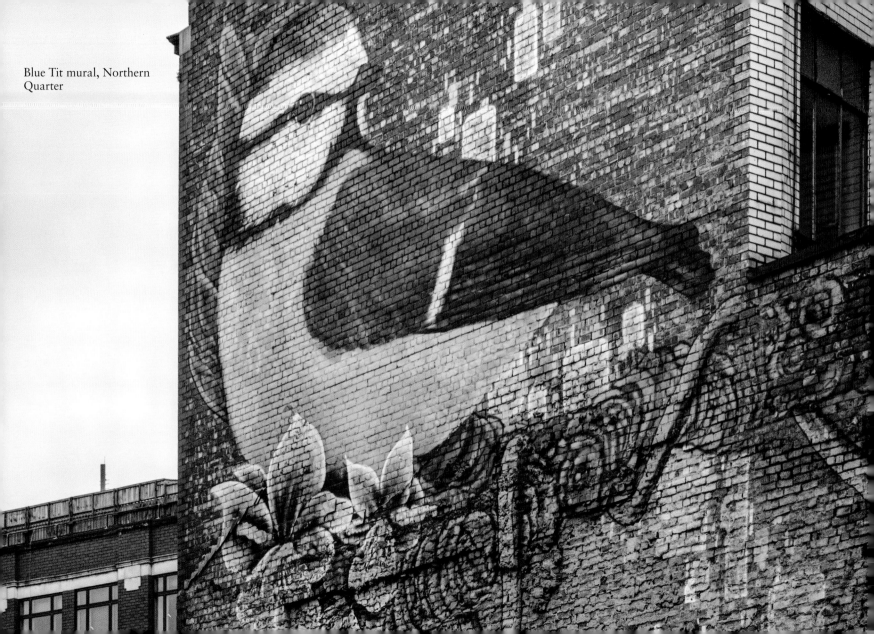

Blue Tit mural, Northern Quarter

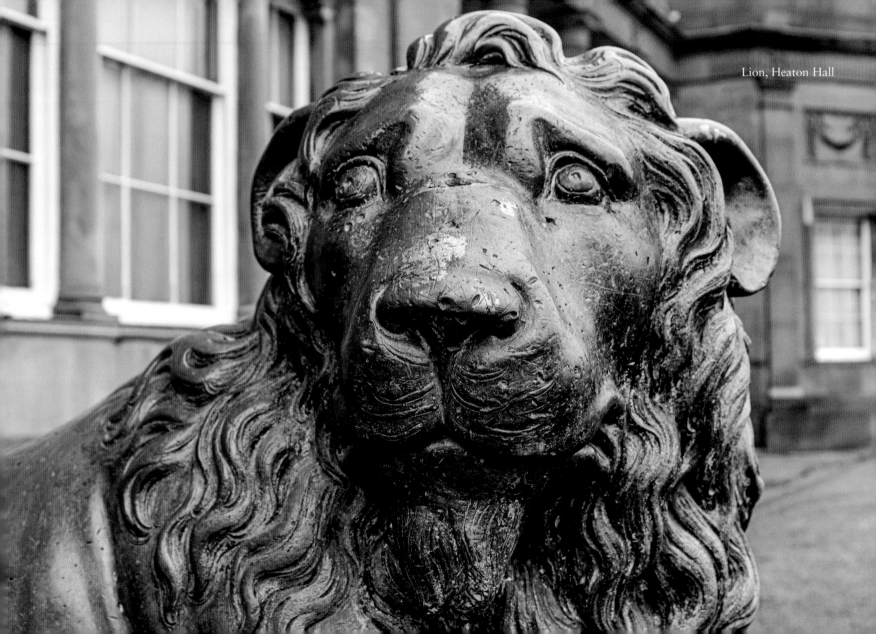

Lion, Heaton Hall

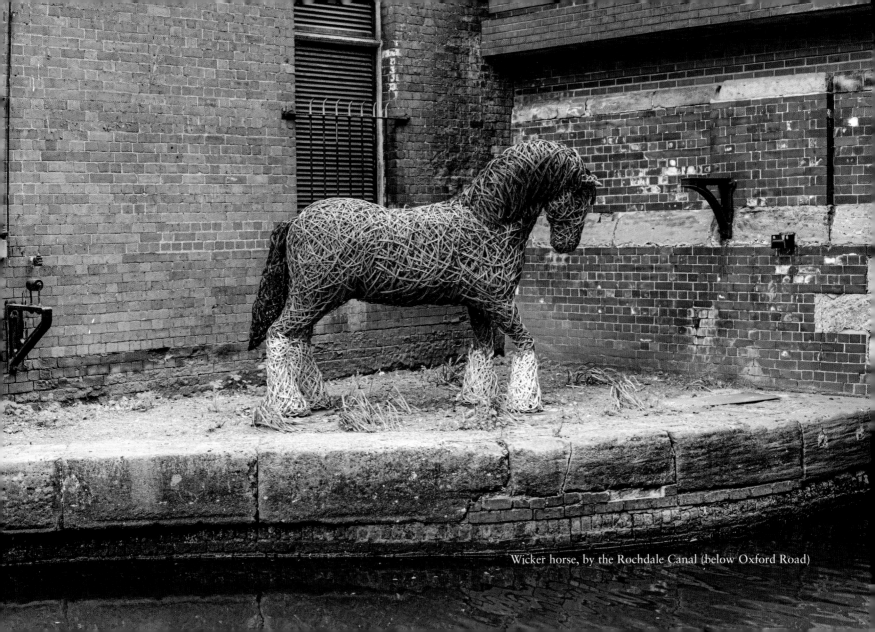

Wicker horse, by the Rochdale Canal (below Oxford Road)

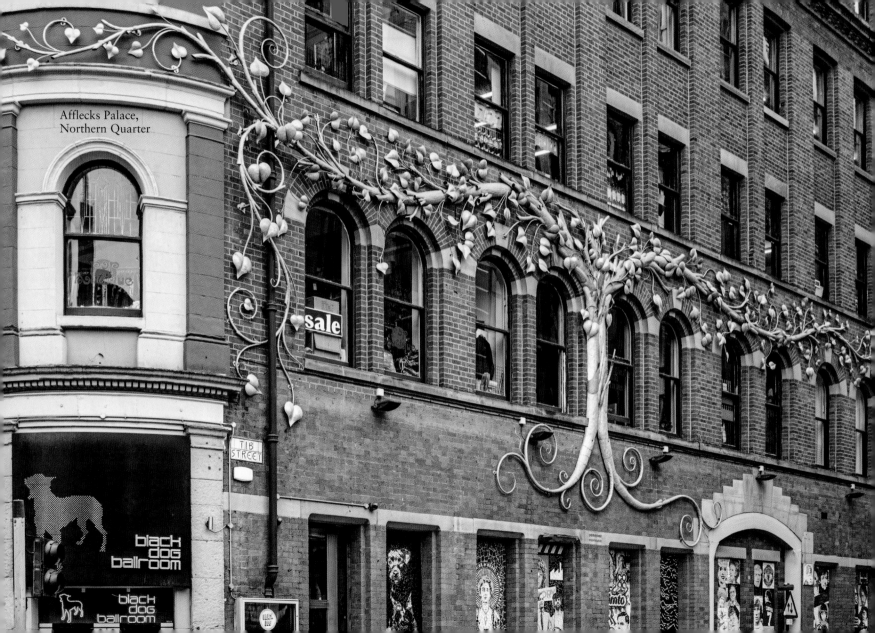

Afflecks Palace,
Northern Quarter

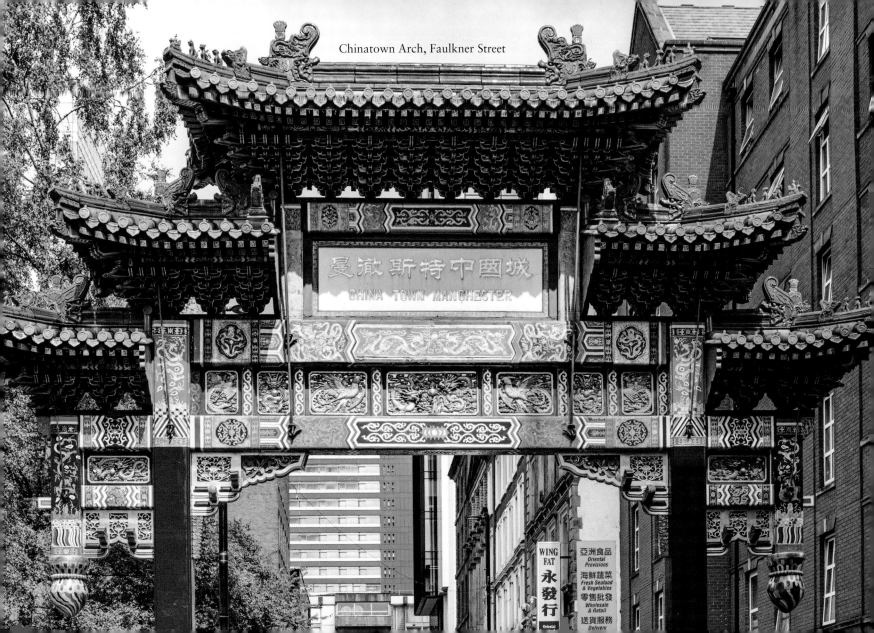

Chinatown Arch, Faulkner Street

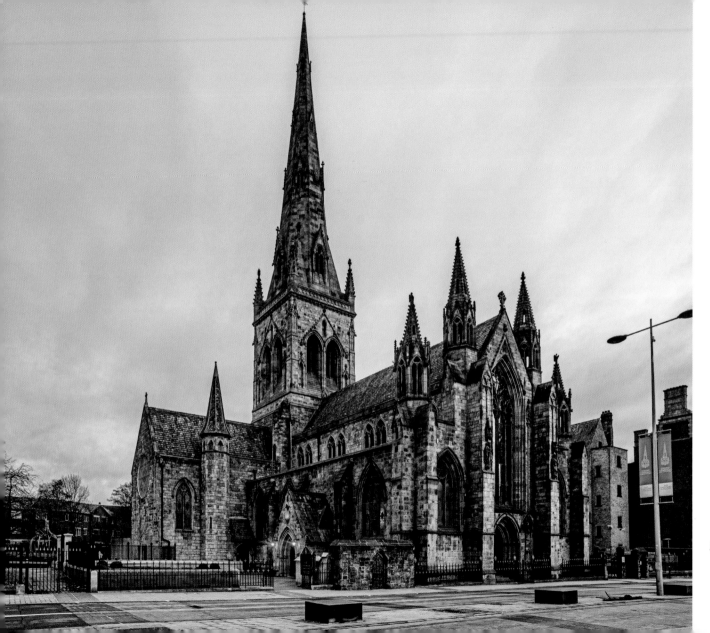

Salford Cathedral

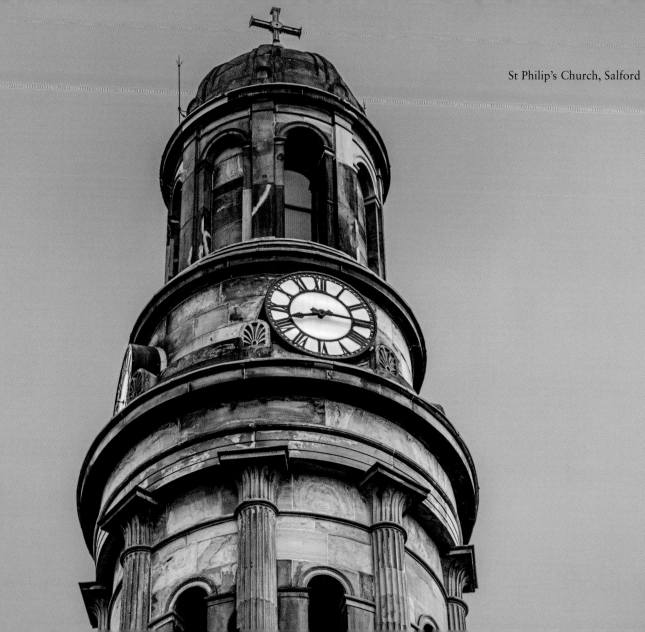

St Philip's Church, Salford

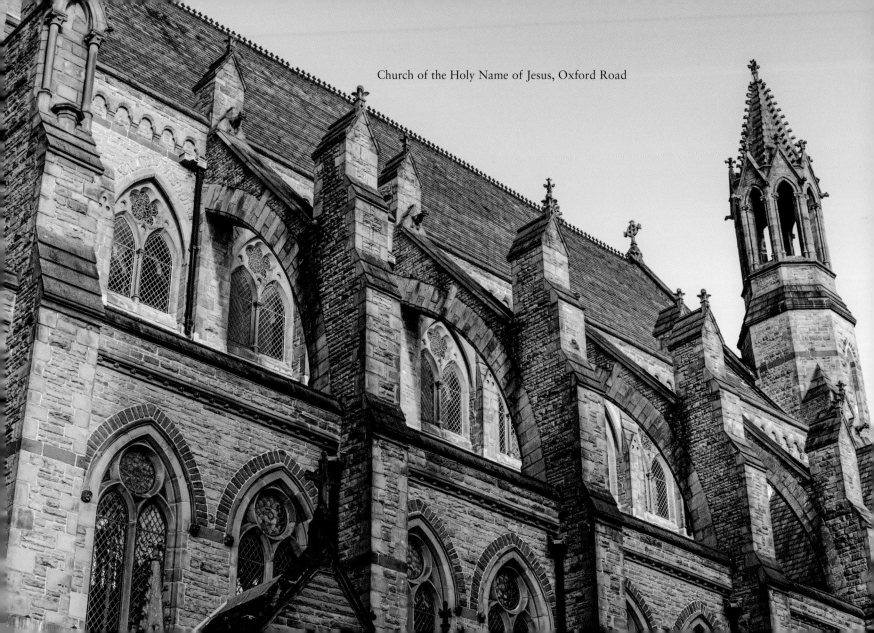
Church of the Holy Name of Jesus, Oxford Road

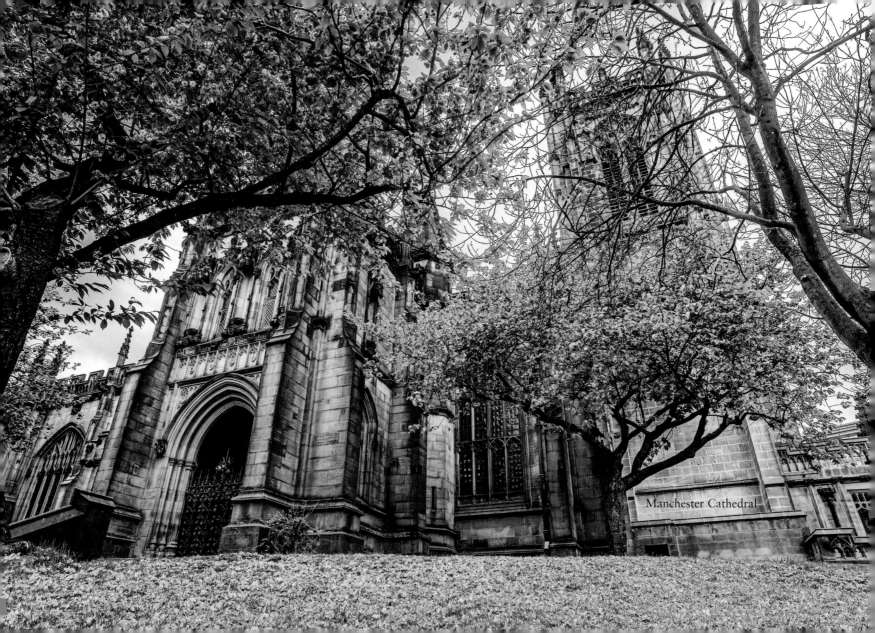

Manchester Cathedral

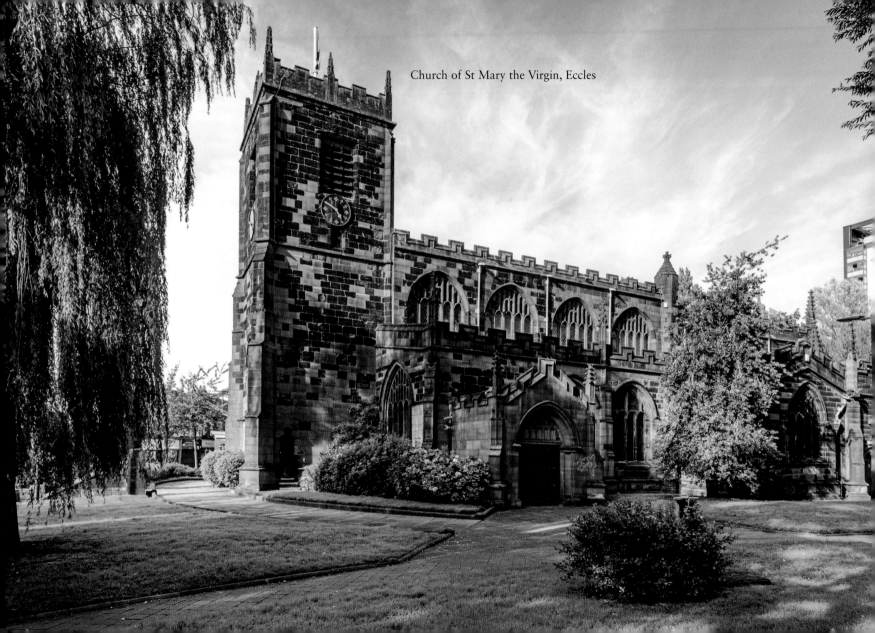

Church of St Mary the Virgin, Eccles

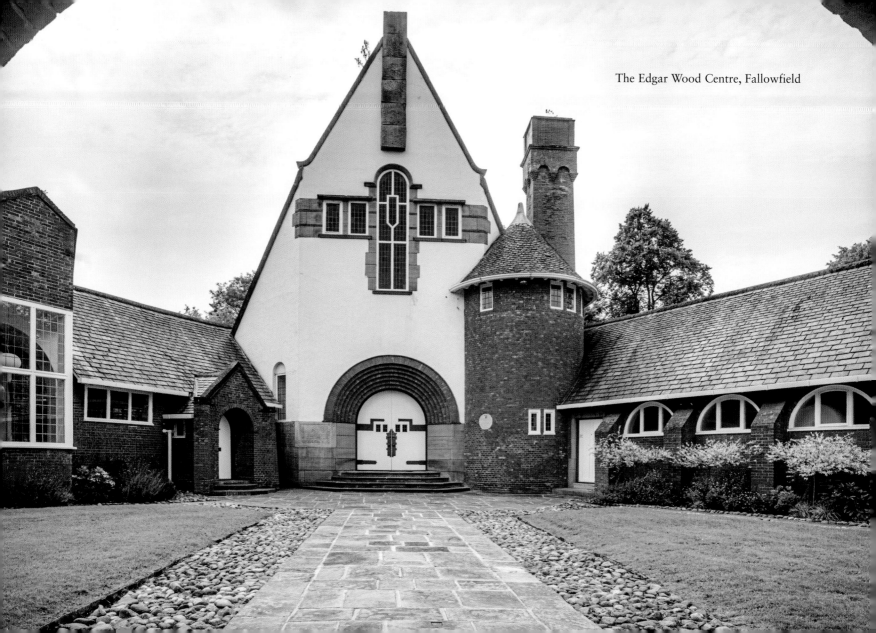

The Edgar Wood Centre, Fallowfield

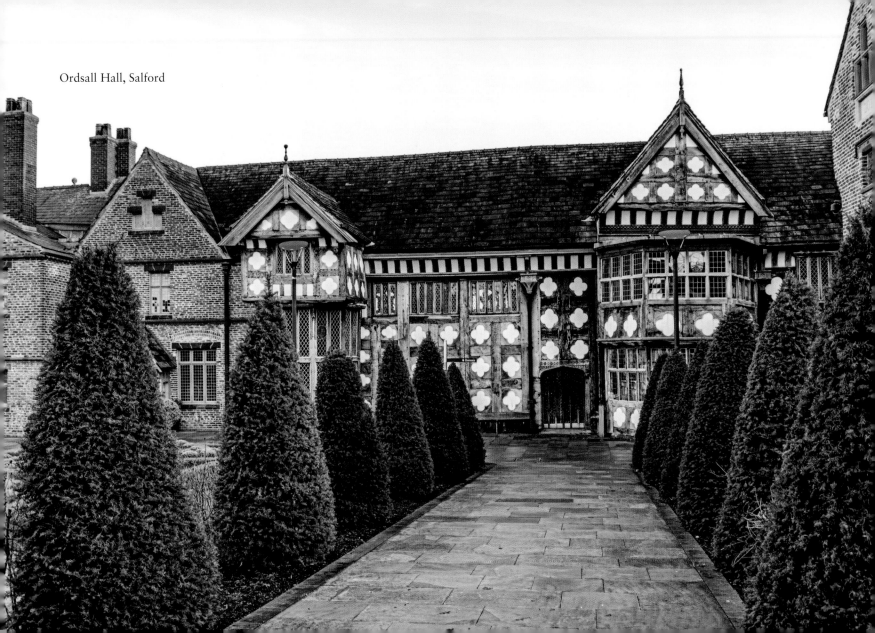

Ordsall Hall, Salford

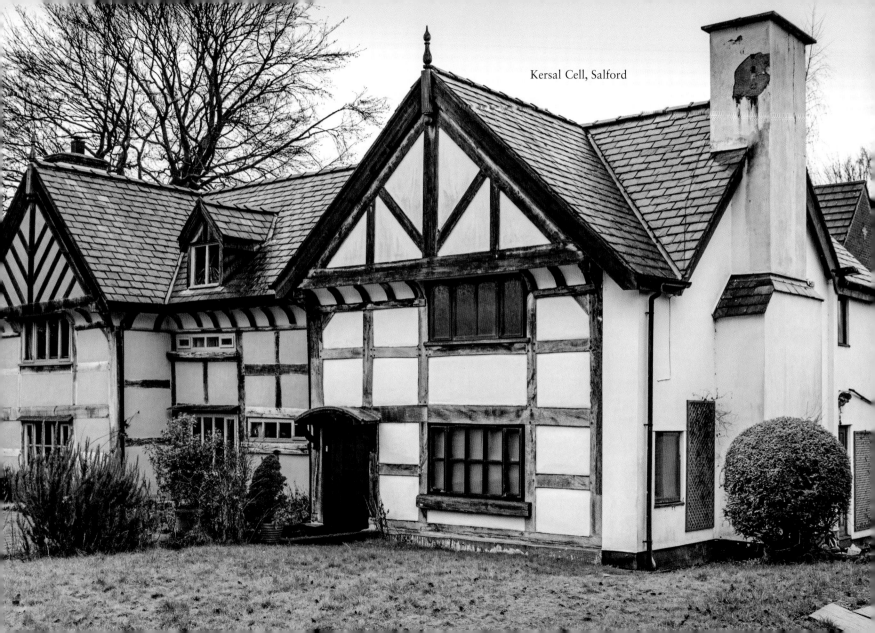
Kersal Cell, Salford

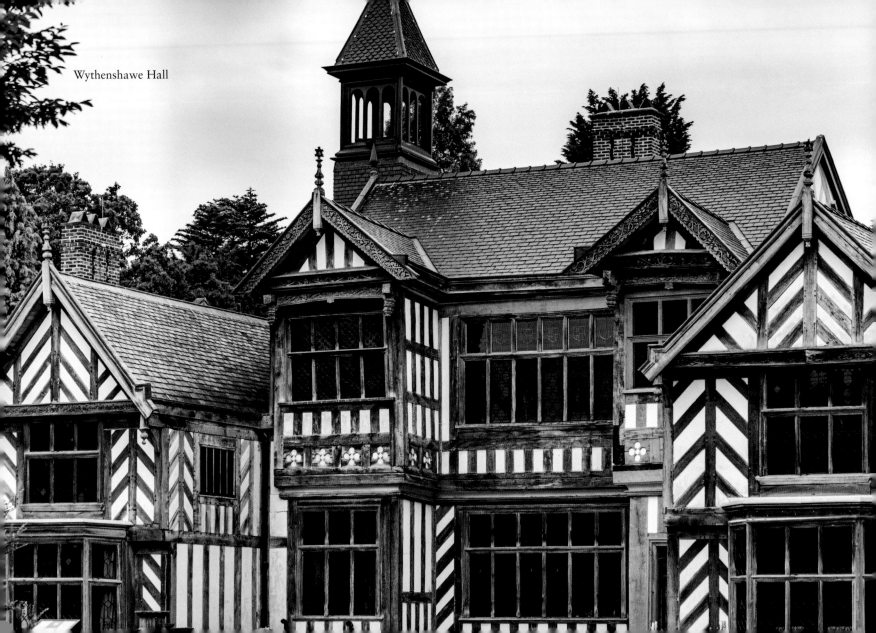

Wythenshawe Hall

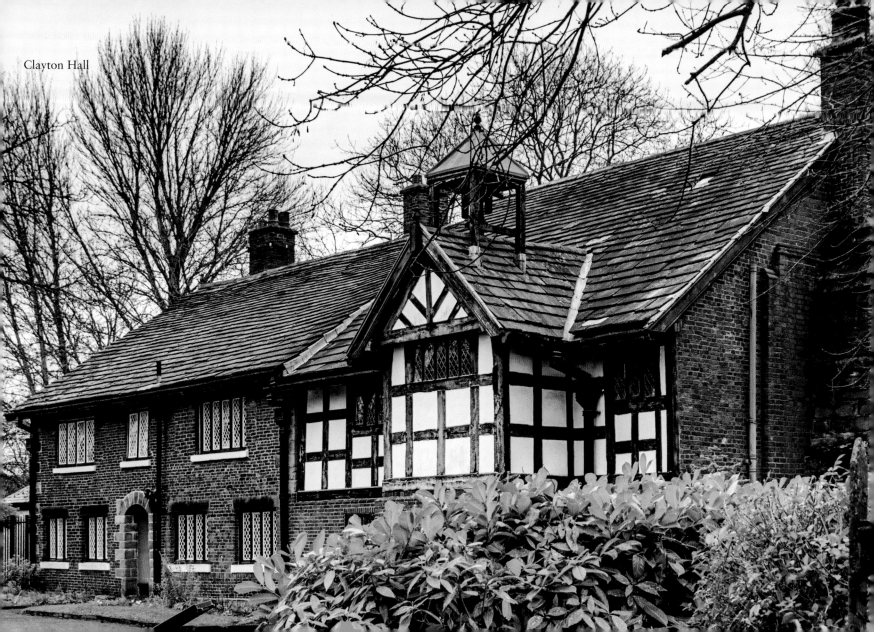

Clayton Hall

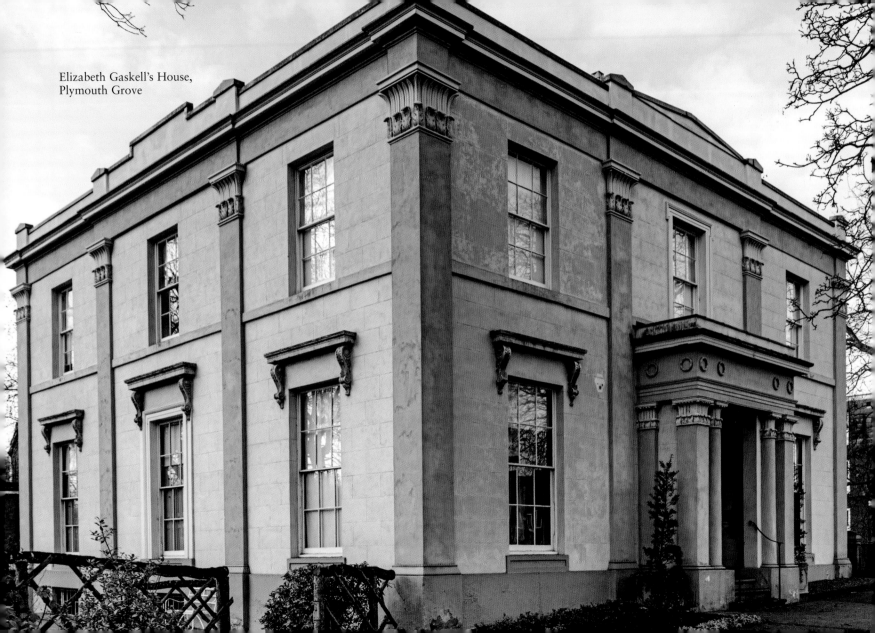

Elizabeth Gaskell's House,
Plymouth Grove

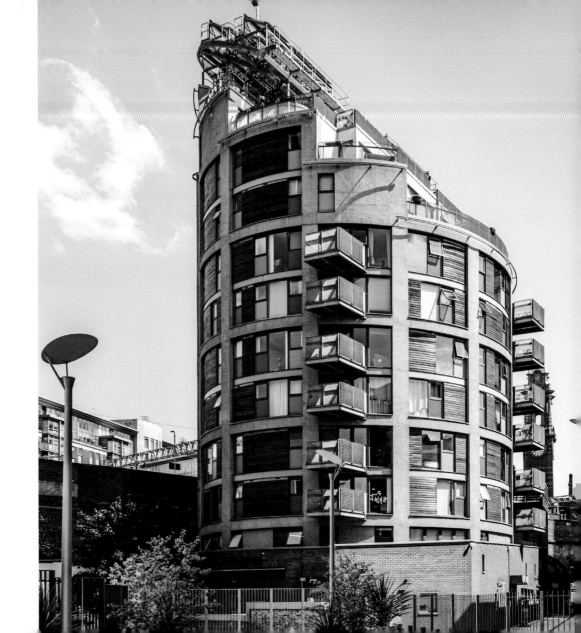

The Green Building, New Wakefield Street

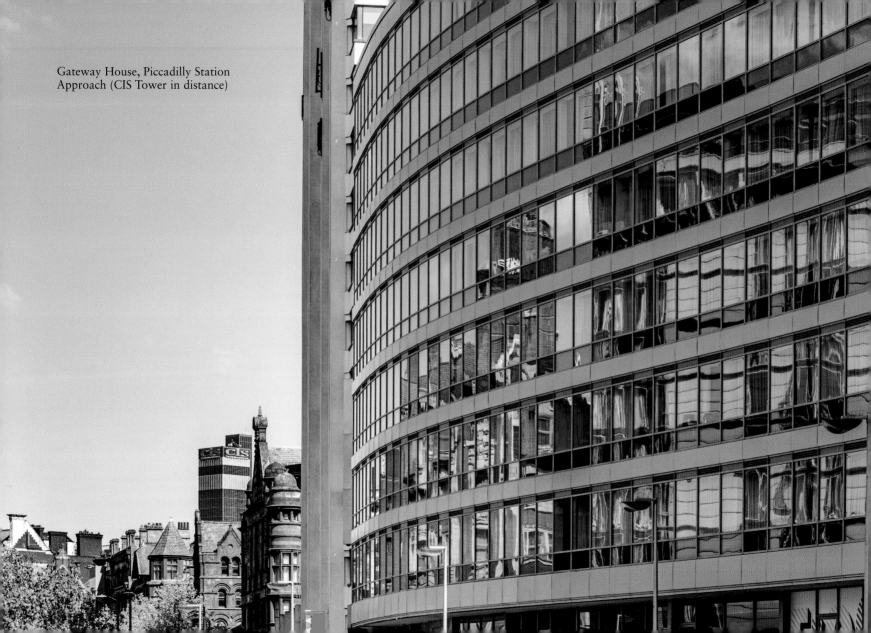

Gateway House, Piccadilly Station
Approach (CIS Tower in distance)

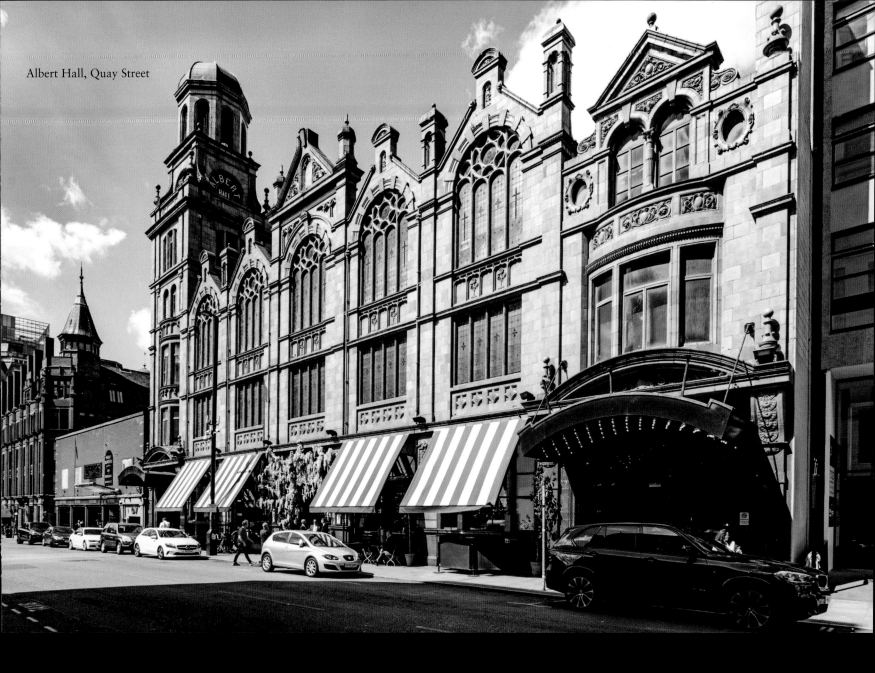

Albert Hall, Quay Street

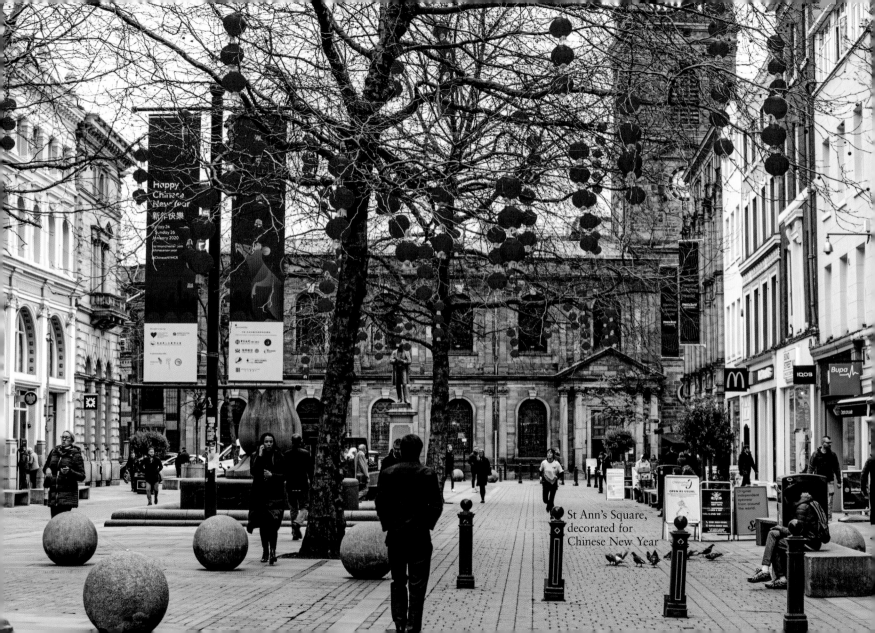

St Ann's Square,
decorated for
Chinese New Year

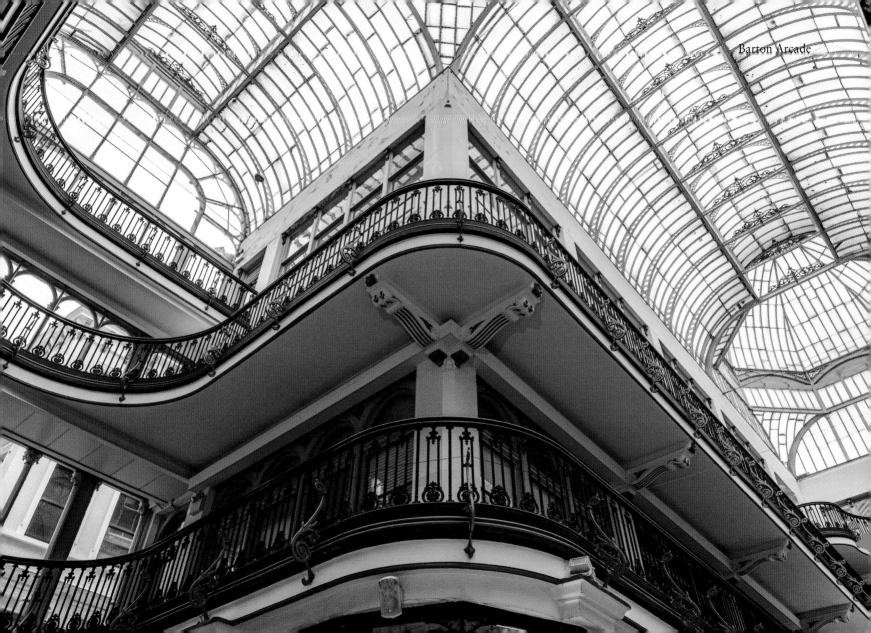
Barton Arcade

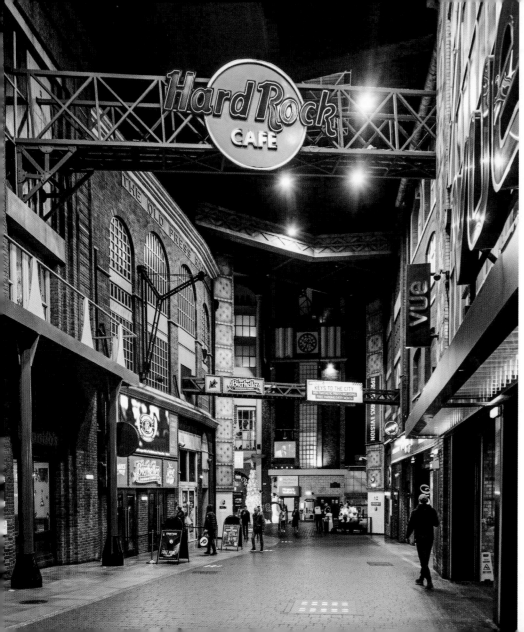

Printworks

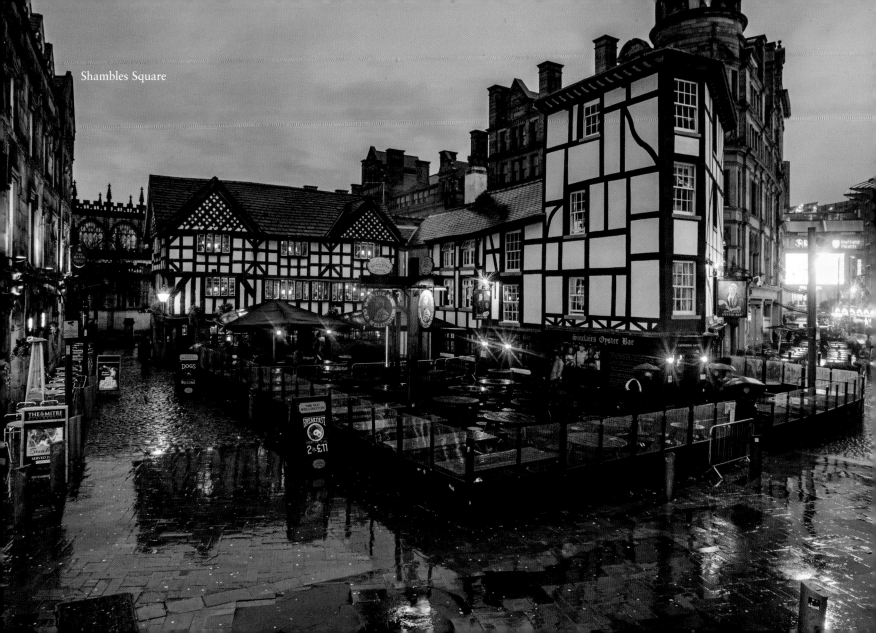

Shambles Square

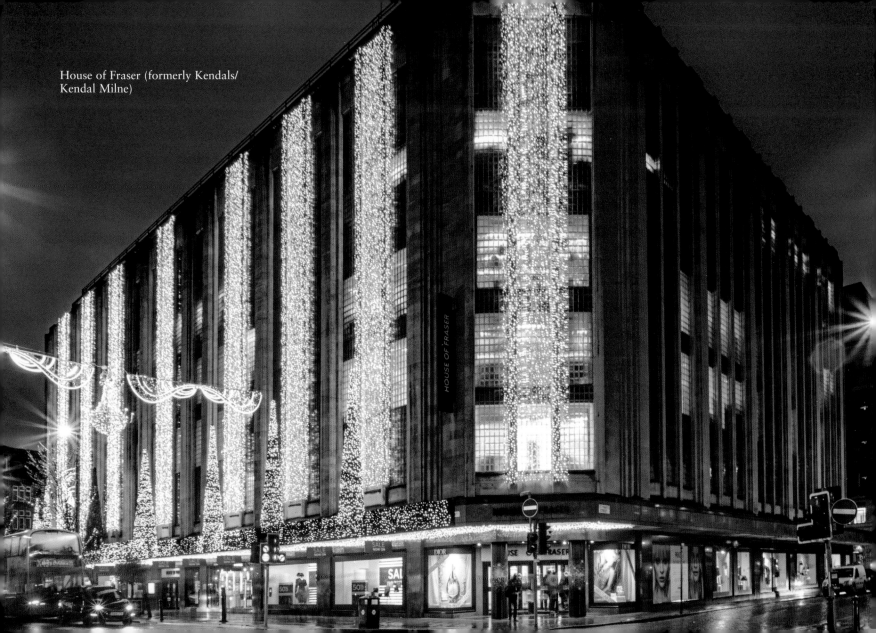

House of Fraser (formerly Kendals/
Kendal Milne)

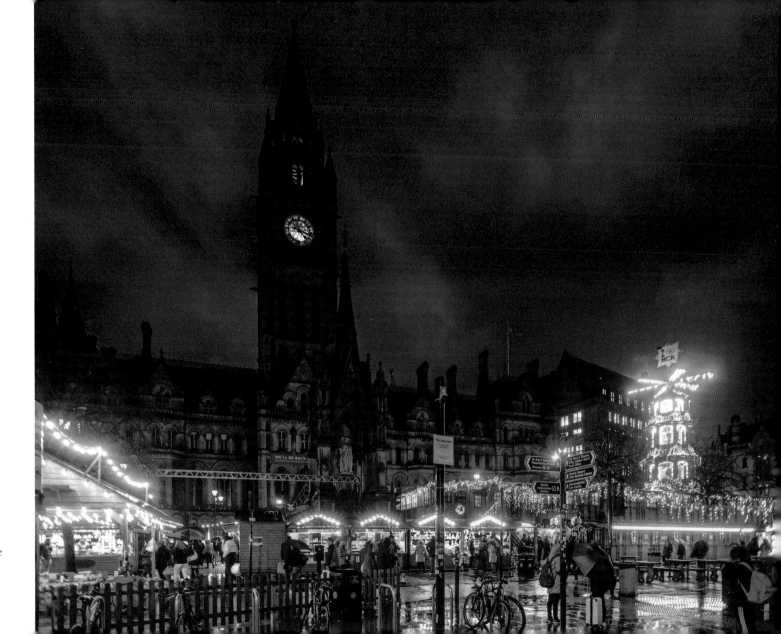

Christmas
Market and
Town Hall,
Albert Square

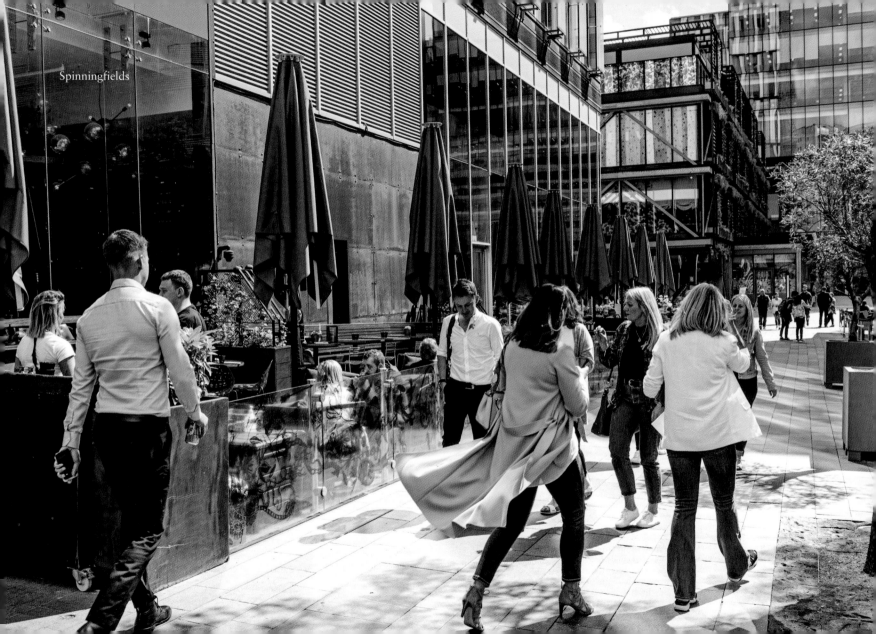

Spinningfields

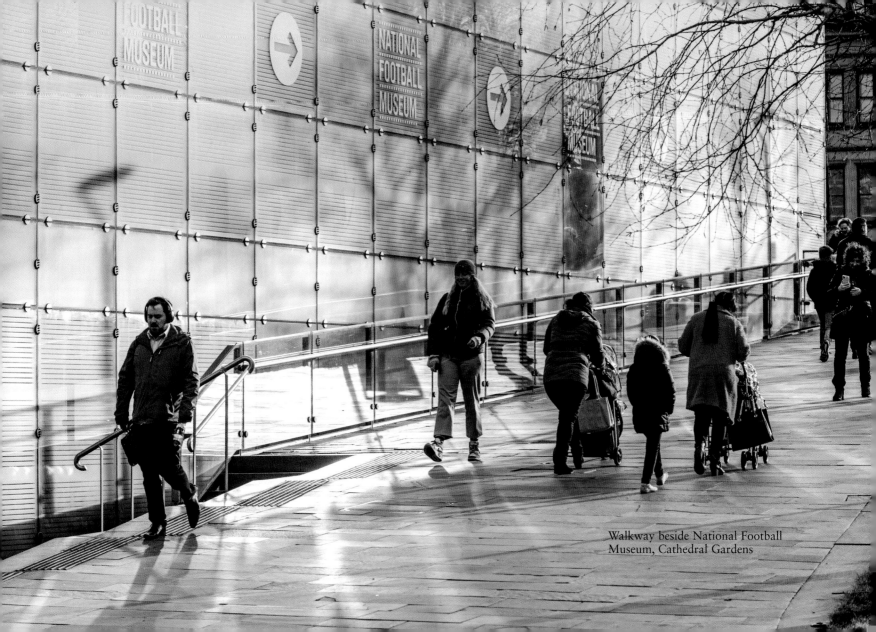

Walkway beside National Football
Museum, Cathedral Gardens

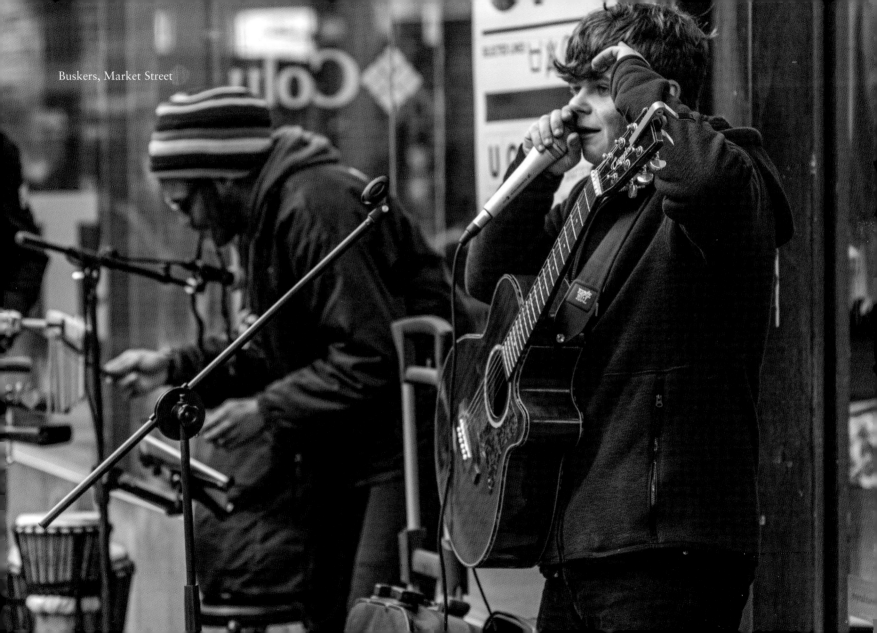

Buskers, Market Street

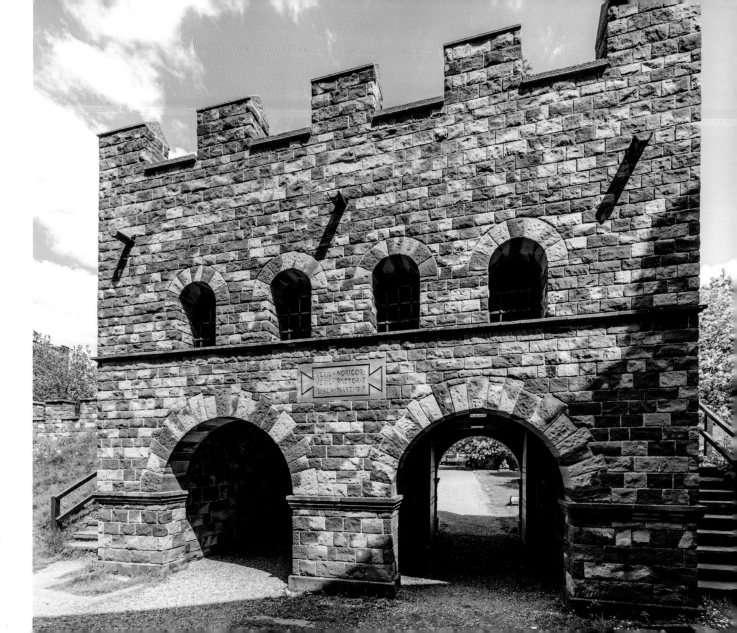

Reconstructed Roman
Gateway, Mamucium

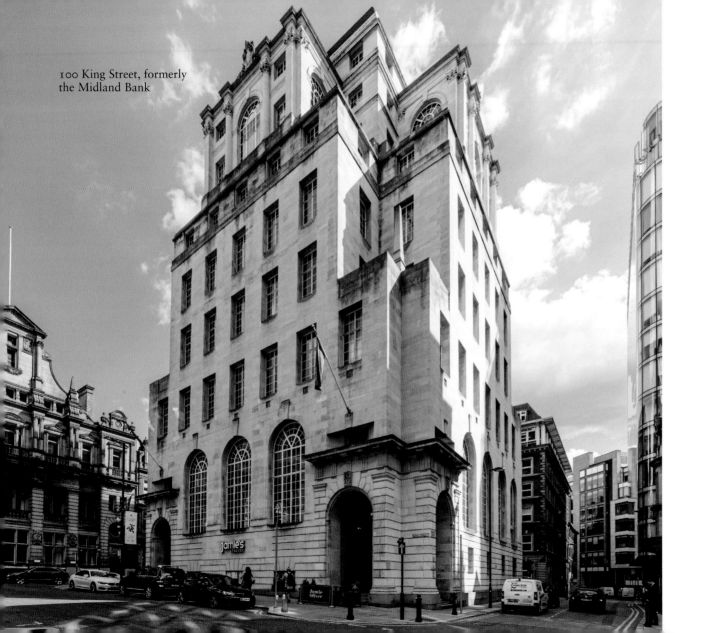

100 King Street, formerly
the Midland Bank

15–17 King Street

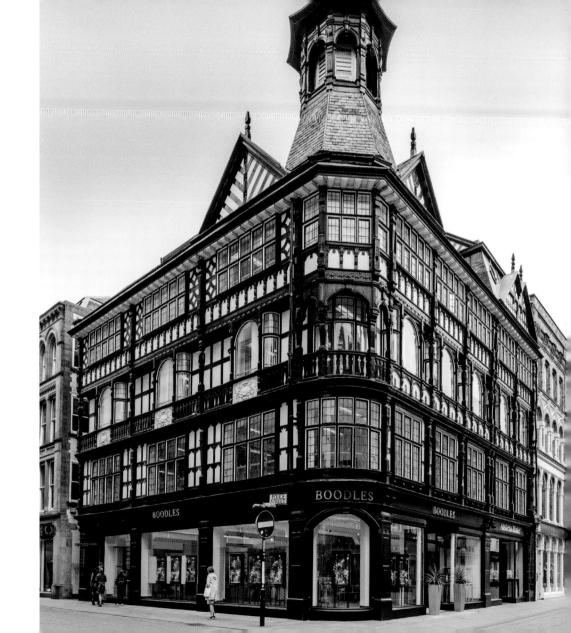

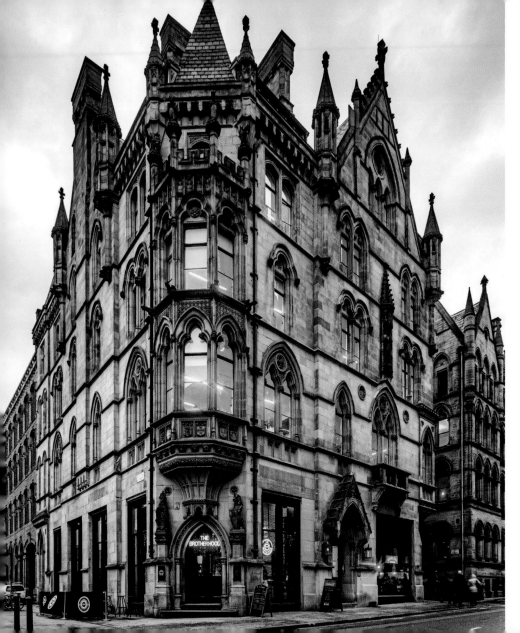

Lawrence Buildings, Mount Street

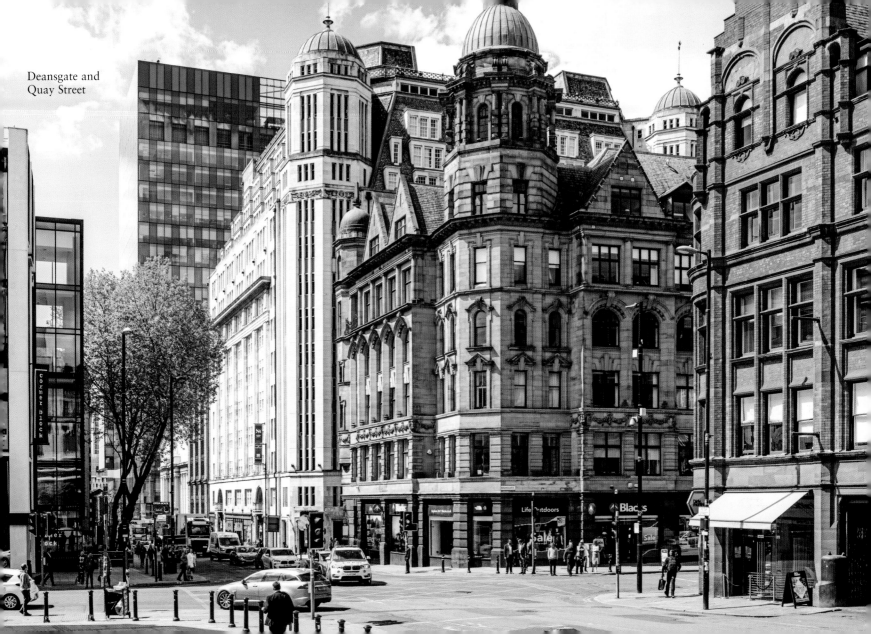

Deansgate and
Quay Street

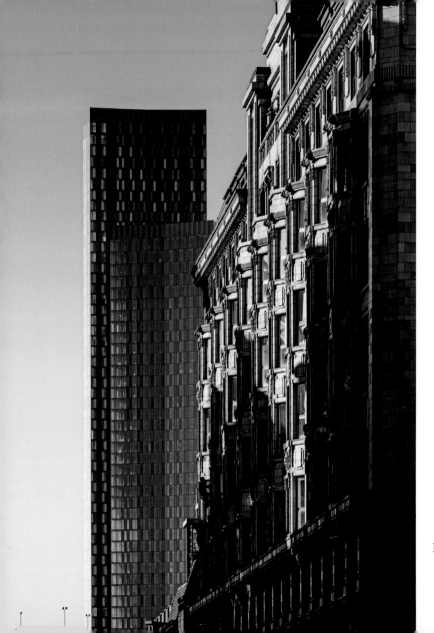

Bridgewater House, Whitworth Street, and Deansgate Towers

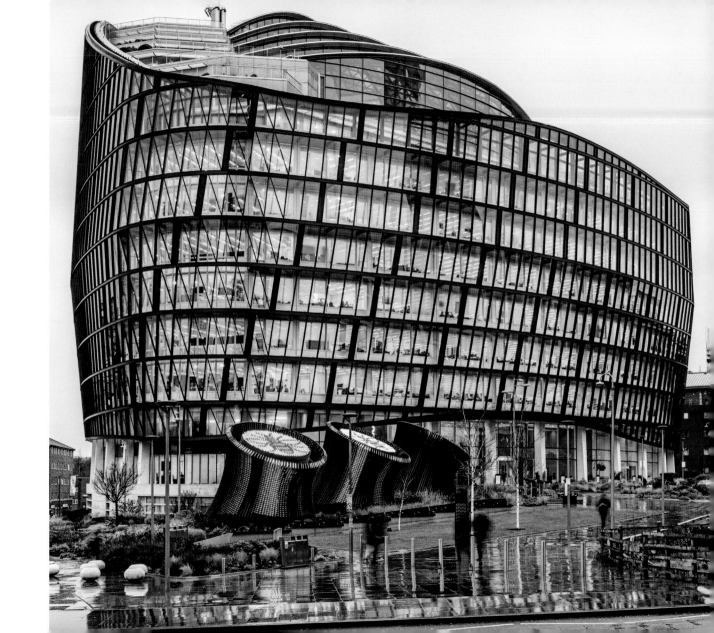

One Angel Square

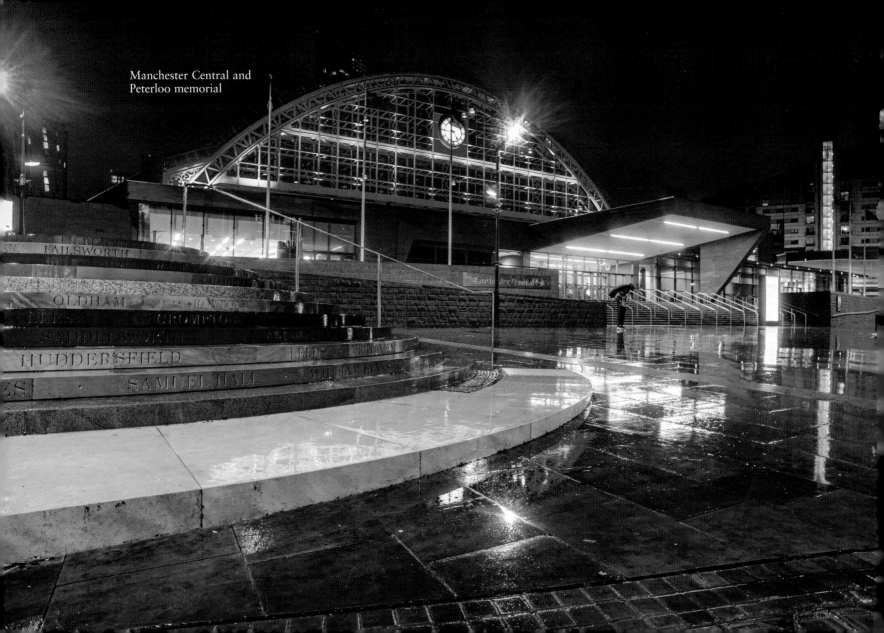

Manchester Central and
Peterloo memorial

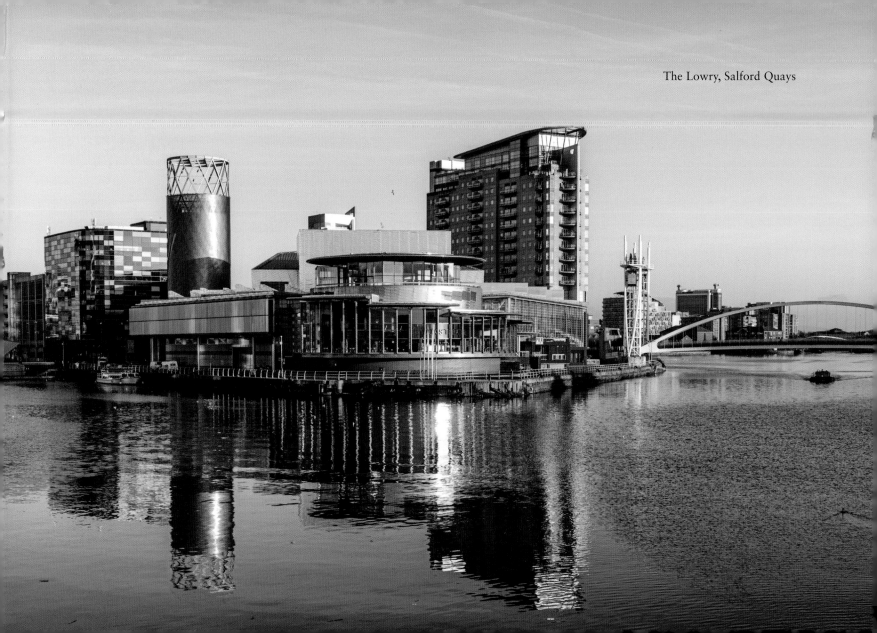
The Lowry, Salford Quays

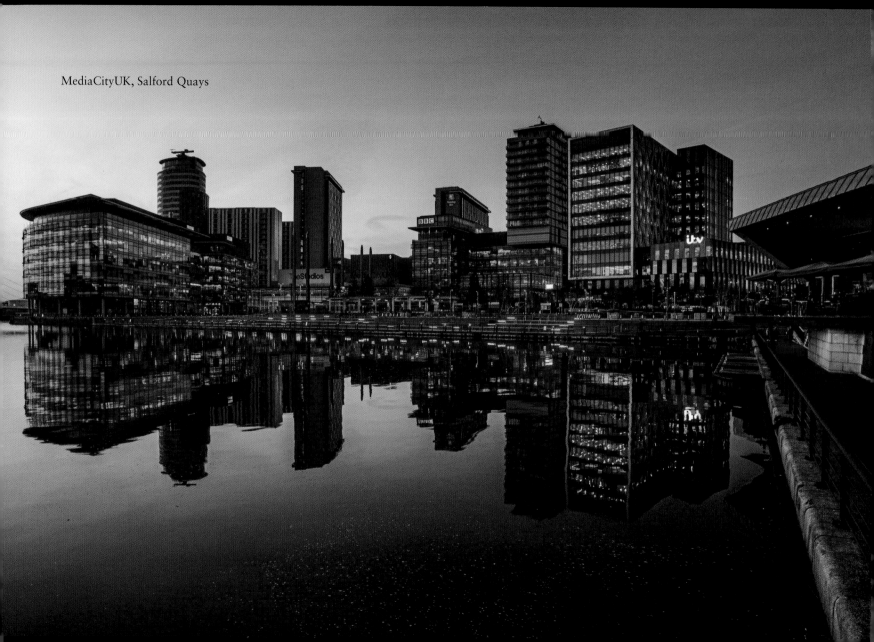

MediaCityUK, Salford Quays

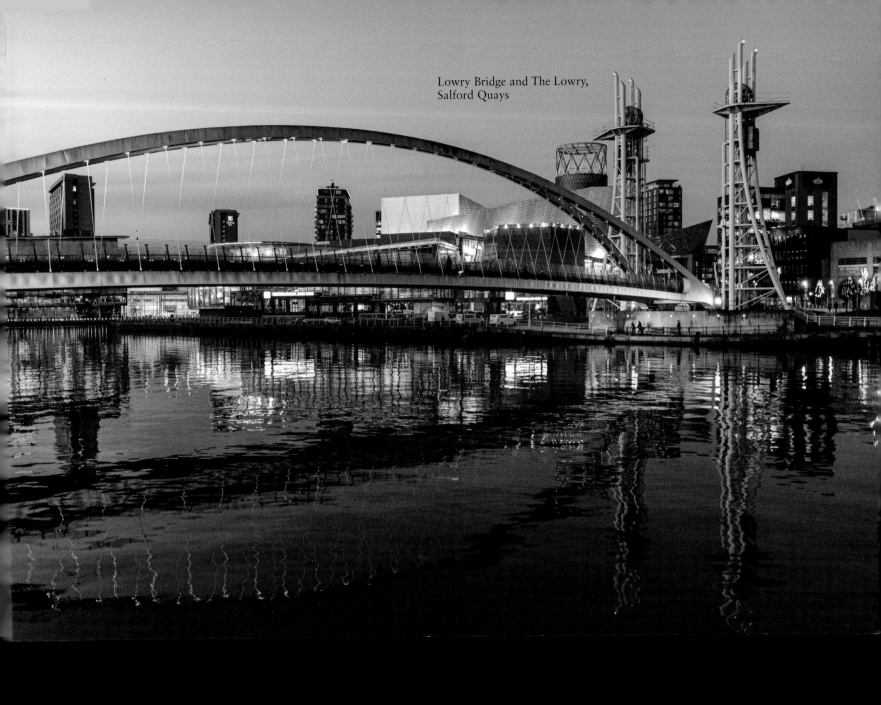

Lowry Bridge and The Lowry,
Salford Quays

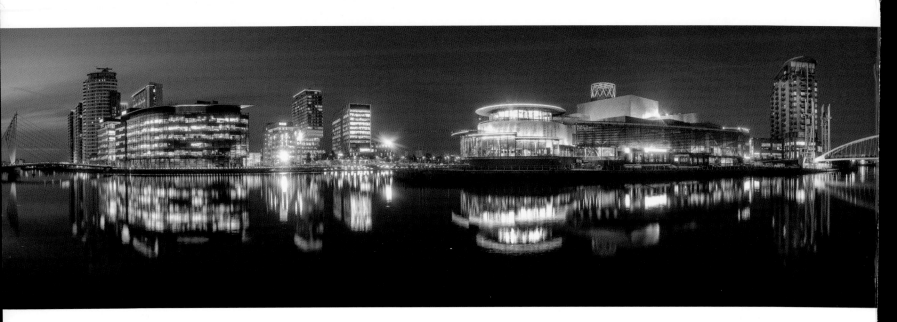

MediaCityUK and The Lowry, Salford Quays